JANE EPPINGA

UNSOLVED ARIZONA

A PUZZLING HISTORY OF MURDER, MAYHEM & MYSTERY

THE
History
PRESS

Published by The History Press
Charleston, SC 29403
www.historypress.net

First published 2015

Manufactured in the United States

ISBN 978.1.62619.826.5

Library of Congress Control Number: 2015943173

CONTENTS

ACKNOWLEDGEMENTS

Many thanks to all the individuals and organizations that helped me try to track down these mysteries. They include the Arizona State Archives, Arizona Historical Society Southern Chapter, Laurie Boone, the Arizona Historical Society Rio Colorado Branch, James Patrick, the Yuma Public Library, the Bisbee Mining and Mineral Museum, Greg Davis and the Superstition Mountain Historical Society. Thomas Bent Jr. generously shared his images and his father's story of the Silverbell relics. Dody Fugate helped with story of her husband's (Paul) disappearance. Johnny Rube, former Yuma County sheriff's deputy, helped with the "Flight into Oblivion" story. Thanks also go to Richard Willey for information on the Tucson meteorites and Sharon Elliot, the hatbox baby. Also many thanks go to The History Press and the editors Christen Thompson and Julia Turner.

Introduction

The stage left Beale Spring about two miles west of Kingman on a June evening in 1880. Four men saw it leave the station with driver Johnny "Jumpup" Upshaw, three passengers and a trunk of gold ingots, valued at $200,000. It was never seen again. Sometime later, "Hualapai Joe" Desredo was killed in a shootout with lawmen. Just before he died, he admitted to robbing the stage and burying the gold but denied harming the driver or the passengers. Desredo claimed that as the stage was leaving after the robbery, he heard wheels crashing against rocks and Upshaw yelling at the horses. Then all was silence, and the stage vanished. Around 1940, a writer, Maurice Kildare, was approached by a hermit, Max Bordon, who had lived most of his life in the Black Mountain Range of Mohave County. Bordon claimed that he had found the stage engulfed by a wide fissure. After swearing Kildare to secrecy, Borden supposedly showed him the remains of the stage with bones inside. After World War II and Bordon's death, Kildare took his tale to the Mohave County Sheriff's Office, but no one was interested. Perhaps this story is just a legend, or maybe there is a treasure of gold ingots out there waiting for someone to find it. We are intrigued by unsolved mysteries because pieces of a puzzle are missing, and that is disturbing. It would seem almost impossible for anyone to totally vanish from the face of the earth at any time. This is especially true in our day and age, when a host of computers track everyone; yet the bodies do disappear with astonishing frequency. In some cases, it may be presumed that people wished to disappear—but then why? Even more unsettling is the realization that certain people might have gotten away with

the perfect crime. Not all unsolved mysteries center on people. The riddle of the Silverbell artifacts is that they are strange objects, out of place and out of time, with only enigmatic clues to their origin. Whether the unsolved mystery is one hundred years old or more recent does not seem to make much difference. It provokes the same measure of controversy. Perhaps the most enduring quality of an unsolved mystery is that it continues to haunt us. I take no stance on these mysteries but leave it to you, the reader.

1

GRAND CANYON AND
COLORADO RIVER MYSTERIES

Pale Ink is better than the most retentive Memory.
—Confucius

It is appropriate that Arizona's unsolved mysteries start in that laboratory of civilization, the Grand Canyon. From ancient to modern times, the Grand Canyon has hosted millions of visitors. Some leave behind their secrets, and the canyon has guarded them well. Those who wish to solve its mysteries for their own reasons come to the canyon and seek out its clues.

While it is now generally accepted that civilization arrived on the East Coast many years before Columbus, evidence is mounting that many people arrived on the West Coast from Asia prior to 1492. If the bones of a Kennewick man were allowed to be studied, there might be even more support for this theory. The human skeletal remains that have come to be referred to as the "Kennewick Man," or the "Ancient One," were discovered in July 1996 below the surface of Lake Wallula in a section of the Columbia River in Kennewick, Washington. Immediately, controversy developed regarding who was responsible for the remains. Claims were made by Indian tribes, local officials and members of the scientific community. The U.S. Army Corps of Engineers (COE), the agency responsible for the land where the remains were recovered, took possession of the bones, but its actions following the Native American Graves Protection and Repatriation Act to resolve the situation were challenged in federal court. Native Americans, who have suffered at the hands of grave robbers and museums, are naturally anxious that their ancestors be buried with respect. However, the remains of

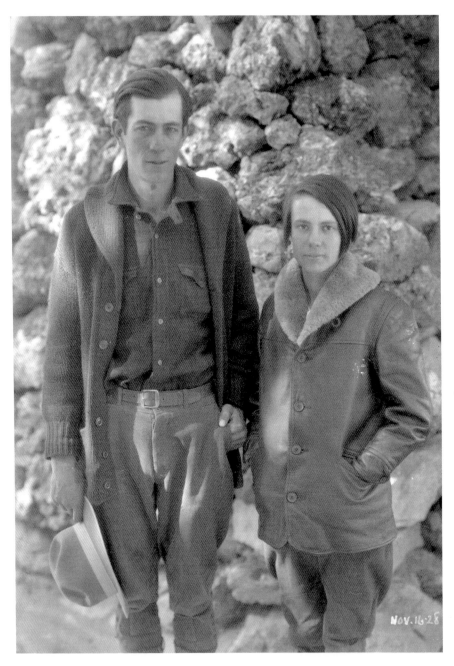

NOV. 16·28

Glen and Bessie Hyde sought adventure in the Grand Canyon but then disappeared, never to be seen again. *Courtesy Northern Arizona University.*

the Kennewick Man are believed to be from much earlier than present-day Native Americans.

In March 1998, the Department of the Interior and National Park Service agreed to assist the Corps of Engineers in resolving issues related to this case. Between 1998 and 2000, the Department of the Interior and the National Park Service, in cooperation with the Corps of Engineers, conducted a preliminary series of scientific examinations of the remains. No fewer than eighteen national and international scientists and scholars conducted this examination with a variety of historical and scientific examinations, analyses, tests and studies.

Rock art dating back several thousand years adorns the walls of the Grand Canyon and provides further evidence that the canyon has been visited by many peoples. Because there are no hard-and-fast rules for interpreting rock art, visitors are left to make their own interpretations. The Zuni of New Mexico have been studied extensively because their language, culture and physical appearance set them apart from other Native American peoples.

The book *Pale Ink* is both a traditional and timely story describing two Chinese explorations in America—one in the fifth century CE and the other in the twenty-third century BCE. The earliest story is a record of journeys that Emperor Shun ordered Yu, his minister of public works, to write in 2250 BCE. Yu, who later became a Chinese emperor, wrote about the mountains and the rivers across the Great Eastern Sea. The fifth century classic *Shan Hai King* was written by a mendicant Buddhist priest, Hwui Shan, who lived in the royal court in China in 499 CE. During his wanderings, he is supposed to have traveled to the country of Fu-sang, where he discovered highly civilized people who could write, weave cloth and make a kind of paper. Hwui Shan said that Fu-sang was located about twenty thousand li from the east coast of Great Han country. (One li equals about one-third of a statute mile.) The people of Fu-sang had no knowledge of Buddhism until they were visited by five priests, including Hwui Shan, from the country of Ki-pin or Kabul. China was fighting a bitter civil war at the time, and Hwui Shan might have fled to what is now Afghanistan. Boatloads of people with their horses left the shores of Asia and crossed the Pacific Ocean, known then as the Eastern Sea, in search of a fabulously rich country known as Fu-sang. One of the country's trees had leaves the color of oak, and in its early stage, its leaves resembled bamboo shoots.

Whenever the king of Fu-sang left the palace, he was preceded and followed by horns and drums. The king took no part in state matters until he had completed the third year of his reign. His people owned cattle with

very long horns. In the year 499, the Liang Dynasty under Emperor Wu-Ti emerged as the victor of the civil war, and Buddhism was back in favor. The emperor appointed one of his overlords to record Hwui Shan's stories, which became part of the Chinese classics. The Chinese generally consigned these stories to the realm of myths and legends, but they have stirred heated controversy among modern scholars. The royal court, upon hearing the stories, evidently found them highly amusing and applauded when they were told that in the Kingdom of Women, the women took serpents for husbands. They said they had never heard tales better told. Henriette Mertz, the author of *Pale Ink*, decided to trace the "vagabonding" priests and reasoned that the Asians had landed somewhere between present-day Los Angeles and San Francisco. The travelers then embarked on journeys inland and visited the "Great Gorge of Great Luminous Canyon," which might have been the Grand Canyon. Hwui Shan records a journey inland of approximately 350 miles that would have taken him to the Mogollon mesa in central Arizona. Traveling north, the priest describes a Black Gorge, thought to be the Black Canyon, and farther on, he discovered a gorge of such singular beauty that it can only be what we have named the Grand Canyon.

Yu served as minister of public works under the Emperor Shun for seventeen years, during which time he compiled the "Classics of Mountain and Sea." Upon ascending to the throne as emperor, Yu sent out men to map the face of the earth. The "Mountains and Sea" described a stream, possibly the Colorado River, flowing in a bottomless ravine. It is said that one Chinese explorer left his lyre in the Grand Canyon, but exactly where is just another mystery.

The Colorado River area contains many mysteries, but none is more enigmatic than the giant intaglios or geoglyphs carved into the desert along the Colorado River from the Gulf of California to southern Nevada. They have been compared to the Nazca Lines or geoglyphs of Peru—giant geometric forms of birds, plants and mammals that were etched into the desert surface of southern Peru. Most of the lines can be dated to the Nazca Culture (100 BCE–600 CE). Several theories have been proposed to explain the function of the lines, but none of these satisfactorily explains the presence of either the Arizona or Nazca geoglyphs. They might have been used in rituals or ceremonial dances commemorating myths. In 1923, George Palmer, a pilot on a flight to Blythe, discovered a human figure with outstretched arms etched into the ground. The Blythe geoglyphs include human and animal figures at three locations with the largest figure measuring 171 feet from head to toe. The Mojave and Quechan tribes of the Lower

Colorado River believe the human figures represent Mastamho, the creator of earth and all life. Several figures occur in the Yuma region with one figure measuring 75 feet from head to toe. Associated with this figure is a cross. Just south of Quartzite are fourteen geoglyphs. The most distinctive is the Bouse Fisherman, who appears to be spearing fish or plunging his spear into the ground searching for water. The Mule Canyon geoglyphs, located near Blythe, consist of clusters of circles cleared in the desert pavement and arrayed in horseshoe-like patterns. Near the Mexican border east of Calexico are the Yuha geoglyphs, which were nearly destroyed by vandals in 1975.

Modern records describe Spanish explorers looking down from the rim of the Grand Canyon at the Colorado River below, feeling fearful. Explored by John Wesley Powell in the 1860s, the Grand Canyon has been the scene of both triumph and tragedy ever since. The Grand Canyon does not give up its secrets easily, and in more recent times, the disappearance of Bessie Hyde and her husband, Glen, while on their honeymoon has continued to intrigue those who would solve the canyon's mysteries. At the time the couple was on their honeymoon, the brothers Emery and Ellsworth Kolb were the foremost photographers of the Grand Canyon. Between 1901 and 1941, they captured the magnificence of the canyon in a way that no one has done before or since. The Kolb brothers moved onto the rim of the canyon to photograph and film the area while constructing a combination home and studio into the side of the cliff. They posted a sign outside their studio that read, "Bright Angel Toll Road. Riding Animals, Pack Animals, Loose Animals, $1.00 each."

By 1928, tourists were paying the Kolb brothers for the privilege of straddling a burro from a nearby stable and riding into the canyon. Not even the Grand Canyon was big enough for the Kolb brothers, who constantly fought until Ellsworth moved. Emery continued the photography business and was surprised one day in November 1928 by Glen and Bessie Hyde, who knocked at the studio door. They introduced themselves and explained that they were honeymooners who had spent the past twenty-six days rafting the treacherous Colorado River. They asked Emery to take their photograph standing on the canyon rim and said they would come back to get the photograph after a hike down Bright Angel Trail. When they returned, their picture was ready for them, and so began their odyssey. Glen Hyde's father, Rollin Charles Hyde, had been a Spokane schoolteacher who homesteaded land in Davenport, Washington. He married Mary Therese Rosslow, a daughter of French immigrants. Rollin, along with his brothers

Samuel and Eugene, embarked on a series of ambitious land transactions in Washington. For a while, they enjoyed wealth and prestige. Then during the panic of 1893, the banks failed, along with the Hyde family fortunes. The family survived this depression, but Rollin no longer had the heart for financial ventures. When Mary's health required a dryer climate, the family moved to California. However, a salubrious climate was not enough, and Mary died of Bright's disease on December 20, 1911. Hyde moved to Prince Rupert, British Columbia, where his son, Glen—now age fifteen, and excelling in academics—began learning the building trade. The family did well for a while, but when World War I broke out, the family fortunes collapsed again. Rollin moved to Idaho with his two teenagers and fifty cents in his pocket. Glen was in and out of school because he had to work on the farm. Still, he did well in his studies and sports. At this time, he became very interested in river riding in what were known as sweep boats.

Much less is known about Glen's wife, Bessie Louise Haley, who was born in Tahoma Park, Maryland, on December 29, 1905. During her early years, her father, William, worked as a wallpaper hanger while her mother, Lottie, took care of the children. Bessie attended high school in Parkersburg, West Virginia, where she wrote poetry and worked on the school yearbook. She went on to attend Marshall College, but in her last year, she eloped with another student, Earl Helmick. Just a few months after the clandestine marriage, Bessie, without Earl, moved to San Francisco, where she attended the California School of Fine Arts. She wrote a poem that might give a clue about why she left.

> *This soft bundle*
> *So close to me,*
> *Is yours and mine*
> *Come, love, and see*
> *I'm glad the stork*
> *In hurried flight*
> *Took time to stop*
> *In here tonight.*

If Bessie had a child, we can only wonder what happened to it. She enjoyed life without her husband in San Francisco. At a dance on a steamer ship plying the waters between San Francisco and Los Angeles, she met Glen Hyde. Glen and Bessie fell in love and wanted to marry, but there was one major obstacle. Earl refused to give Bessie a divorce. Also, Bessie's mother,

Lottie, did not care for Glen, but she favored Earl. Bessie took up residence in Elko, Nevada, where the divorce laws were more lenient than in Idaho. After their divorce, Earl Helmick remarried. He lived into his nineties but would never discuss his marriage to Bessie, her disappearance or whether there was a child.

On April 12, 1928, Glen and Bessie were married in Twin Falls in an Episcopal church. Both had a taste for adventure, and before long, the lure of the Colorado River called them. On October 20, 1928, after the autumn harvest, Bessie and Glen assembled supplies, launched their scow onto the Green River and set out on their fateful journey. They intended to float almost 660 miles and meet Glen's father at Needles, California, no later than December 11. The first phase of their trip, from their starting point to Lee's ferry, was fairly uneventful. Here Owen Clark, who was in charge of keeping records at the ferry, advised the young couple "not to put all their eggs in one basket" and urged them to take a second boat with them. They refused. After a while, they floated onto the Colorado River, and on November 12, the couple rode out of Marble Canyon and entered the Grand Canyon proper. They would ultimately arrive at Emery Kolb's door.

After taking their picture, Emery asked them about their boat, and they explained that they had built it themselves in Idaho and that they planned to navigate it through the Grand Canyon. He was not favorably impressed with the boat. Kolb was shocked that despite the dangerous rapids, they did not carry life preservers. He strongly warned them against such recklessness. Glen laughed off the admonitions, but Kolb noticed that Bessie seemed nervous about the journey ahead. Emery, always delighted to visit with river people, presented them with his autographed book, gave them lunch and invited them to his nightly lecture. Bessie enjoyed a hot bath and a good night's rest. The next morning when the couple prepared to depart, Kolb's daughter, Emily, came out of the studio to greet the young couple. Emily was neatly dressed, and Bessie Hyde took one look at her own worn clothing and said, "I wonder if I shall ever wear pretty shoes again." The couple embarked on their trip, and Bessie never wore pretty shoes again. Emery would later write to the future senator Barry Goldwater:

> *I entertained them and offered them life preservers and every assistance. They refused the life preservers and every assistance. I then tried to persuade them to go over to the garage and get some inner tubes but all they did was look at each other and smile. We believe the bride was ready to quit here.*

They did not show up at Needles as planned, and Glen's father became very worried. He immediately offered a $1,000 reward for locating the missing couple. He set up searches for the couple and wired Emery Kolb: "Could you be induced to search river with boat El Tovar to Diamond Creek or farther?"

Bessie's final words haunted both Emery and Emily as Emery set out to do his part in the search. History was made as army planes launched the first Grand Canyon air search. The army scheduled two small Douglas single-engine observation planes to search the river. They were piloted by Lieutenants John Quincy Adams and William G. Plummer. Each plane carried a mechanic and food and clothing to drop in case they spotted the couple. Preston P. Patraw, assistant superintendent of the Grand Canyon National Park, and Bob Francy, supervisor of trail rides for the Fred Harvey Company, were each accompanied by an army pilot. The flight through the narrow Grand Canyon gorge was frightening, as the wing tips almost touched the canyon walls. The air search was aided by a private Fokker Tri-Motor from California. At the point of Grand Wash Cliffs, Adams and Plummer spotted the Hydes' scow calmly drifting in the river. They swooped down for a better look but could not find Glen or Bessie. After relaying directions to the site, the airplanes had done their job, and they headed back to California. The story captured the attention of the national media, and the Associated Press wired Kolb: "Will be glad to pay you liberally for any pictures found in the Hyde Scow. Appreciate having some negatives rushed here if good. Advise us, collect."

Emery hiked down from the rim to join the rescue party. Ellsworth—along with Jack Harbin, a brakeman for the Santa Fe Railroad, and Bob Francy, a former barnstormer—returned to the canyon to join the search. The rescue party found the scow just above mile 237, floating on water just thirty feet from the shore. All of the Hydes' gear was securely stowed, and Glen's 30-30 rifle rested in a corner. Emery's autographed book, which he had given the couple, was wet but readable. The rescuers found Glen's and Bessie's hiking boots, Bessie's camera and film and a baked ham and sack full of flour. A small suitcase contained Bessie's better clothes. She made a notebook entry on November 30 indicating that they had passed Diamond Creek before they disappeared. On the gunwale, the Hydes had carved forty-two notches—one for each day of their journey. Everything was stowed neatly in place, but Bessie and Glen were nowhere to be found. The rescue party combed the area, but it appeared that the couple had vanished without a trace.

The rescue party met Rollin Hyde back at Peach Springs on December 27, 1928, and gave him the couple's personal effects. They could not offer much in the way of words of encouragement. They found no tracks, and it was as if the couple had simply vanished into thin air. The Kolb brothers took Bessie's film back to the studio for developing. Over the next couple of years, various search parties looked for the Hydes to no avail. Emery Kolb underwrote at least one search but then backed out. Rollin Hyde wrote to Bessie's mother: "I am glad that I went back to the river and made my way on foot all the way along where the accident happened. I made certain that if Glen and Bessie had gotten ashore they would have gotten out. The people in this vicinity tell such stories of the country and that there are few places one can get out. This was my worst worry that they were trapped between the river and the rim. I satisfied myself that this could not be."

Over the years, the legend of Glen and Bessie Hyde grew, along with the popularity of river rafting. River guides would recount and embroider the various versions as they took folks down the river. On one trip in October 1971, Dale Billingsley was telling the story on the Grand Canyon Expedition twenty-day oar trip when a passenger—Elizabeth "Liz" Cutler, a sixty-one-year-old retired schoolteacher from Pomeroy, Ohio—said that she was really Bessie Hyde. Billingsley and the rest of the rafters were stunned. The shocked guide asked Cutler what had happened. She claimed that Glen had become abusive and to protect herself, she stabbed him to death and hiked out of the canyon. She said that after killing Glen, she turned the boat loose and walked downstream all the way to Peach Springs, where she caught a Greyhound bus and went back east. Cutler became the subject of an article by *Outside Magazine* and NBC's *Unsolved Mysteries*. Martin Anderson, a river historian, researched Elizabeth Cutler, and it turned out that she was actually Mary Elizabeth Arnold, born on December 2, 1909, in Pomeroy, Ohio, and had nothing to do with the Hydes. When Cutler, some seventeen years later, was asked about her confession, she denied any knowledge of it or the Hyde name. She might have realized that someone might believe her and that there is no statute of limitations on murder.

The mystery of Bessie and Glen Hyde remains unsolved, and their bodies were never found. Both families eventually accepted the deaths but were forever haunted by questions of how it happened and what became of the bodies. An added smidgen of confusion came into play when Emery Kolb died on December 11, 1976, after a lifetime of superb photography and of fighting with his brother, Ellsworth, and the National Park Service. When his grandson, Emery Lehnert, went to clear out Emery's personal effects,

he climbed into the rafters of his grandfather's garage and received a shock. Suspended in the rafters was an old canvas boat that boatman Dave Russ had given Kolb years earlier. In the boat were a complete skeleton, a small bundle of clothing fragments and a human skull. Dr. Walter Birkby of the Human Identification Laboratory in Tucson identified the skeleton as that of a male about six feet tall and twenty years old. Moreover, Dr. Birkby found a bullet in the skull. However, he determined that the skeleton was not that of Glen Hyde. And so the Grand Canyon continues to protect its tantalizing secrets.

2
THE SILVERBELL ARTIFACTS

The Silverbell artifacts, strangely out of place and time, were discovered a short distance from the banks of the Santa Cruz River, near Tucson, Arizona, in 1924. Charles Manier found the first artifact, a large lead cross, while he and his family were returning from a picnic at Picture Rocks, northwest of Tucson. To this day, the Silverbell artifacts stimulate quarrels ranging from scholarly discussions to shouting matches. Besides the profusion of Latin inscriptions, they are adorned with crudely drawn heads, altars, angels, axes, doves, temples, crowns, snakes, a few Hebrew words, menorahs and other undetermined symbols. On several artifacts, a "map" of Britannia, Gaule, Romani and Calalus appears.

For most people, Calalus, an unknown land, causes the biggest dilemma because we know of no country or area, ancient or otherwise, with this name. Some insist the Silverbell artifacts are a hoax. Still others make a case for the symbols being derived from the Freemasons of Mexico. Mormons have sought clues in the inscriptions to substantiate their doctrines. Was the banished King Israel III described on one artifact, the bearded white man of the Toltec tradition? Are these relics what they purport to be, a record of people of Roman-Jewish descent who, after 125 years in Calalus, came to a violent end through a revolt of natives whom they had pressed into their service? America's ancient history has mostly been ignored by academics; however, it is now accepted by many scholars that there was considerable maritime activity in the New World before Columbus made his discovery.

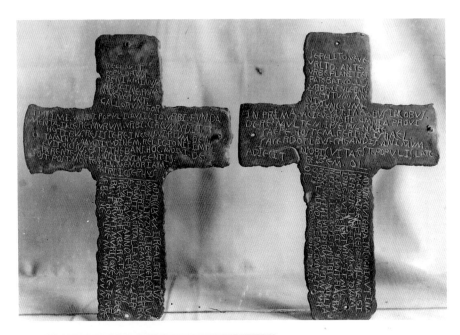

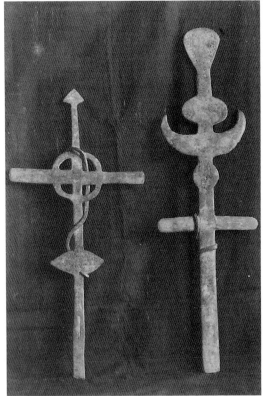

Above: The Silverbell Crosses are covered with strange inscriptions in Greek and Latin. *Courtesy Tom Bent Jr.*

Left: These Silverbell relics depict Islamic and winding snake symbols. *Courtesy Tom Bent Jr.*

Shortly after World War I, veteran Thomas Bent Sr., on the advice of his doctor, moved to Tucson from New York. About the same time, Charles E. Manier came to Tucson from Ohio. Both men sought a warm, dry climate to relieve their respiratory problems. Bent and Manier became acquainted in Tucson through participation in various veterans' organizations.

The artifacts were discovered in the vicinity of an old limekiln along present-day Silverbell Road. The kilns, constructed in the 1880s of adobe bricks, were lined with firebricks. With the heat from burning lime, the adobe bricks became hard and impervious to weather. These kilns played an important part in early Tucson architectural history, when lime plaster was used to cover adobe bricks and lime was used to process silver. Today, only the ruins of one kiln remain. As Manier explored the footpath leading into the opening of a kiln, an object jutting out of the ground caught his attention. It was solidly embedded in caliche, and it is on its stability that the authenticity of the Silverbell artifacts could rise or fall. Manier got his pick and shovel, which everyone who drove a car in those days carried, and began chipping away at the caliche around the object. It turned out to be a large lead cross, eighteen inches long, twelve inches wide at the cross-arm and two inches thick. At first, he thought he had stumbled on a headstone for a modern grave. When the family got home, they washed the cross and discovered that it was constructed in two pieces. Manier pried the two sections apart and found that the inside of each piece was covered with strange inscriptions, as well as liberally coated with a foul-smelling substance resembling beeswax.

The substance was turned over to the University of Arizona. Some say a graduate student threw it out because of its noxious smell while others contend an analysis was made but lost. An analysis would not have proved the antiquity or origin of the artifacts, but if the substance was of a commercial nature, then the artifacts could be classified as modern.

Manier took the cross to Dr. Frank Fowler, head of the Classical Languages Department of the University of Arizona, who recognized the inscriptions as Latin. His translation of the first cross is as follows:

Provehimur pelage: We are carried forward on the sea
Calalus: ? (an ancient land?)
Terra incognita: An unknown land
Populum late regem: a people widely ruling
Toltezus: [?]
Silvanus: [?]
Traductic sundt: They were transferred

Theodorus: Theodore
Subucie urbe Rhoda: Near the city Rhoda
Et plus: and more
Septingentia: Seven hundred
Capti nullus auro: Bribed by no gold
Urbe eximentur: They will be taken from the city
Theodorus vir summae virutis: Theodore, a man of highest virtue
Regnat inter annos quattuordecim: He reigns for fourteen years
Iacobus regnat sex: Jacob reigns for six
Deo adiuvante non timendum: God helping nothing is to be feared
in nomine Israel: In the name of Israel
Consules urbium magnarum: Consuls of great cities
Com septinti militibus: With seven hundred soldiers
AD. DCCC: [?]
Kal. Ian: The first of January
Urbe renatus Iacobus: [?]
Deo iuvante: With God's help
Regnat Iacobus: Jacob rules
Manu forti: With mighty strength
More maiorum: After the customs of our ancestors
Contag(e) domino: Sing to the Lord
Fama semper vivat: May his fame live forever

Manier then approached Thomas Bent, who had helped him process claims as a disabled veteran, and urged him to take an interest in the artifacts. At first, Bent was interested only to the extent that they could sell the sixty-two-pound relic for its metal content. When Bent became involved in the mystery, the two men formed a legal partnership. On November 28, Bent and Manier made their first excavations and unearthed more artifacts. Because of health problems, Manier needed to live in town, so Bent took up residence and homesteaded on what was then public property. Further excavations produced a total of thirty-two artifacts, most in the form of crosses, but also including an Islamic crescent, batons, swords and spears. All are of lead, except for one piece of caliche, which has drawings and inscriptions. The items were buried at a depth of three and a half to six feet. As Manier and Bent continued their work, Fowler and other professors from the University of Arizona became involved with the excavation.

A Mexican laborer who had worked on the original construction of the limekilns recalled finding lead swords and some bones in the same area almost

forty years earlier. He had given them to his children to play with but had no idea what had happened to them. Newspapers were free with speculation about the origin of the artifacts. "A few are broken, as though done in combat, and the general disposition of these finds portrays the confusion of a pitched battle." Laura Coleman Ostrander, a Tucson High School teacher, suggested the inscriptions might be a record left by a band of eighth-century Roman-Jews, who called America Calalus.

Dr. Andrew E. Douglass, director of the Steward Observatory; Dr. Byron Cummings, director of the Arizona State Museum; Dr. Charles Vorhies; and Dr. Clifton J. Sarle from the University of Arizona—all active participants in the excavations, at least in the beginning—believed the artifacts were an ancient history of people living on the banks of the Santa Cruz River. The ninth artifact, discovered on March 4, 1925, stirred the greatest controversy. The tube of its pipe-like handle and the underside of its spearhead showed fresh scratches, which might have been made during excavation. These scratches caused some to whisper the ugly word "planting." Bent contended that the scratches did not occur during the last few minutes of the excavation, but were made accidently while the artifact was discovered.

Dr. Neil Merton Judd, Cummings's nephew from the Smithsonian Institution, worked at the site on May 27, 1925. One artifact was so firmly embedded that he had to remove his coat and "expend more energy than he had anticipated." He declined to work on another artifact, indicating that he had used the pick enough for one day. Judd expressed the belief that the artifacts were probably no older than 1540 CE and that he did not believe fraud was involved. The real battle was fought in the newspapers. The *New York Times*, ever skeptical of the discovery, pointed out that the relics contained such dates as AD 775, and the *Anno Domini* system did not come into general use until about AD 1000. The undaunted *Arizona Daily Star* proclaimed that the artifacts were authentic based on Cummings's finds. In a statement to the press, Cummings said:

> *I don't see how they can be fakes. Anyone who says they are, cannot have investigated. I saw only one of the articles uncovered by Dr. A. E. Douglass, Director of the Steward Observatory at the university, and Dr. Frank Fowler, Professor of Classical Literature, have seen several of them taken out. They agree with me that the objects are not fakes and were not planted there, but are of great antiquity.*

The *Tucson Daily Citizen*, which criticized everything in the *Star*, including the accuracy of its weather reporting, sided with the *Times*. The *Prescott*

Courier summed up the situation: "What does a newspaper know about tablets with inscriptions on them anyway? If they were aspirin tablets, it would be different." Not all New York writers were ready to rule out the artifacts as a hoax. One reporter who visited the site wrote:

> *The combination of Christian cross, Moslem crescent, Hebraic seven branched candlestick and Free-masonry emblems have imposed a heavy tax on the credulity of investigators, but their appearance of having been covered and embedded in stone by natural processes has puzzled skilled archaeologists. Some have arrived at the opinion that, whatever their origin, the objects lay for centuries in the earth where they were found.*

The *Citizen* trumpeted banner headlines, "RELIC TEXTS ARE CRIBBED FROM DICTIONARY GLOSSARY." E.S. Blair, a Cornell attorney and a Latin hobbyist living in Tucson, pointed out that several of the inscriptions contained modern English and French words such as "Gaul" and "Seine"; that the Latin was classical, not eighth century; and that Christians did not study Hebrew in Europe during the dark ages. Dr. Emil Kraeling, a Hebrew scholar from New York, translated the Hebrew words, which included *elohim*, "God"; *kadosh*, "holy"; and *shemona peoth*, "eight sides." He concurred that Christians would not have studied the Hebrew language.

The *Star* defiantly proclaimed, "If Dean Cummings says they're genuine, they are, declare Tucsonans. Harold Bell Wright, Albert Steinfeld, Mayor John E. White and Mrs. Allie Dickerman were among those who back relics." Leandro Ruiz recalled a sculptor who had lived at the site of the artifacts. Ruiz, by that time ninety years old and almost blind, had ranched in the Silverbell area in the 1880s. He recalled that a family by the name of Odohui (probably Oro-Ruiz) lived near one of the limekilns with their son, Vicente, a sculptor. Ruiz was quite impressed with the boy's sculpting ability. Vicente had a macabre sense of humor. Once, when Ruiz fell from his horse and was knocked out, Vicente placed a stone cross at his head, on which was inscribed "Ruiz." Ruiz recalled, "I saw him [Vicente] make a stone cross. I also saw a metal horse that he had made, and the mould in which the metal for the horse had been poured. I did not, however, see the metal horse in the making. I saw him carve some letters on the cross, but I do not know in what language the inscriptions were made."

Vicente Odohui came to Tucson with his parents around 1886. His father, Timoteo, told friends that he had been a mine manager in Zacatecas but had to leave Mexico because of political difficulties. Eduardo Machado said that the family, who showed culture and breeding, had brought a couple of burlap sacks

full of books, many of them Greek and Hebrew classics. People came from miles around just to hear them converse in perfect Spanish. Ramón Fimbres, who had lived at another limekiln near the Odohuis, doubted that Vicente had the ability to make the crosses. He said the boy, who appeared unstable, was obsessed with buried treasure. The father burned lime under a concession from Tucson merchant Albert Steinfeld. After about eight years, Timoteo died, and the family returned to Mexico, never to be heard from again.

The *Star* dug in its heels deeper, reporting, "Cummings Firmer Than Ever in Belief That Tucson Artifacts Are Genuine." Cummings reported that the crosses were received with interest but skepticism from the American Association for the Advancement of Science. He established the age of the relics through the Roman script contained on them, which had not been in common use since the eighth century. By now, accusations of "planting" and "hoax" were rising above the whisper level, and the question centered on whether the artifacts could have been planted in caliche, sixty-five inches below the surface. Dr. Gurdon Montague Butler, dean of the College of Mines and Engineering from the University of Arizona, in a statement to the press indicated that there was no evidence of burial in recent years and no evidence of the earth's being disturbed. Dr. Charles Vorhies wrote:

> *I was satisfied from my own observations that the overlying layers of gravel, caliche, and soil, had not been disturbed by human agencies in recent or historic times, and that they had every appearance of having been laid down by natural processes. The caliche layer in which these objects were imbedded was overlain by two other similar layers. There was no appearance of these objects having been placed beneath the ground even at a remote date by burial.*

Manier and Bent suffered ridicule during the excavation. People came in at night to dig on their property, forcing them to post a guard. The Pima County Sheriff's Office ordered Bent and Manier to quit digging up Silverbell Road, which was being done by others over whom they had no control. Except for the one inscription on caliche, all of the artifacts are predominantly made of lead, containing traces of gold, silver, antimony and arsenic. Three mines in the district could have produced the lead ore: the Old Yuma, the Goat Ranch mine or the Old Padre. Dr. A.E. Douglass wrote, "It seems to me impossible that these articles could have been put into the ground in recent years, nor do I see any signs of Spanish influence. Their position in the firm caliche indicates a great age. I believe it important to continue this search in the expectation that other similar relics will come to light."

At a public meeting in 1926 at the University of Arizona, Cummings and Douglass presented an illustrated lecture on the Silverbell artifacts. At this meeting, professor of geology Dr. F.L. Ransome attacked the conclusions of the speakers. He branded the artifacts as "puerile toys" and expressed the opinion that they were the work of one man, and that man apparently demented. He also stated that the caliche in the limekiln area was of a different composition than that normally found in the Tucson area. In early 1928, an attorney from Rochester, New York, George M.B. Hawley, visited the site and talked with Bent, Manier, Sarle, Ostrander and Cummings. He evidently developed a bitter animosity toward the artifacts and the discoverers. Hawley prepared a manuscript disproving the artifacts and discrediting the people. "These artifacts were the work of two, and I know their names—in fact interviewed them in the attitude of an ignoramus, and after I had convincing evidence of their work; and in each case I was practically kicked out."

Hawley accused Laura Ostrander and Clifton J. Sarle of being the perpetrators of the hoax. He died before his manuscript was published, or he most certainly would have been sued. Probably some artifacts were lost during the excavation. The laborers were excavation men accustomed to moving large quantities of earth from one site to another at the going rate of about two dollars a day. They never could understand why anyone would pay them just to look for artifacts. Two items were recovered from excavated material that had been piled up for hauling away. From the middle of January to early March 1928, the University of Arizona had complete control of the excavation. Manier and Bent excluded themselves from any participation. This group uncovered four spearheads and handles. Under the bombardment of accusations of hoax and fraud and the inability to come to terms with Bent and Manier, the University of Arizona withdrew its support of the excavation project. By 1930, the University of Arizona had completely withdrawn from the venture. Limited excavation was carried on by Bent and other interested individuals.

John Bent, brother of Thomas, uncovered a broken handle of a spear in 1930. This was the last artifact of record. All of the known Silverbell artifacts are now at the Arizona Historical Society in Tucson. Unfortunately, the Silverbell artifacts have met with ridicule and condemnation. It would be very interesting to know who made them and why. Perhaps we will never know, but we should try to find out. As late as 1956, a University of Arizona professor, Emil Haury, who, at the time of the discoveries, was a graduate student and worked on the excavation, stated that he believed that four rough pieces of uninscribed lead were planted even while they were digging.

3
LUST FOR THE DUTCHMAN'S GOLD

L ust for gold has sent many to Arizona's Superstition Mountains in search of the Dutchman Jacob Waltz's gold. These gold-seekers have been described by western writer J. Frank Dobie as Coronado's children. As for Jacob Waltz, he left several riddles: "From my mine you can see the military trail, but from the military trail, you cannot see my mine. If you pass three red hills, you have gone too far." These may just be the Dutchman's way of easing our greed. So far, no one has found the gold, and a few, such as Adolph Ruth and Walter Gassler, have either found their deaths or simply disappeared in trying to pursue it. Like so many before and since, Adolph Ruth was obsessed with finding the Lost Dutchman's treasure in the Superstition Mountains. This mountain range is located mostly in Pinal County and partially in Maricopa County, Arizona. One of the legends is that Miguel Peralta, a miner from Mexico, conducted expeditions into the Superstitions around 1848 and brought out large quantities of gold that he removed to Mexico. Apaches murdered the Peralta miners either for their gold or because they resented their invasion of Apache lands, but at least one Peralta is presumed to have escaped.

Around 1878, the Dutchman Jacob Waltz staked a claim on a rich gold vein in or near the Superstitions. Many people tried to trail the Dutchman to his mine; however, none succeeded, and several are reputed to have died by his hands. Just before Waltz died in 1884, he was supposed to have given the location and a map to a neighbor, a black woman by the name of Julia Thomas Schaffer.

Adolph Ruth believed that he had the map that would lead him to fortune. *Courtesy Superstition Mountain Historical Society.*

The disappearance and death of the gold-seeker Adolph Ruth in June 1931 still generates controversy and adds to the lore of the Superstition Mountains. The grisly circumstances surrounding Ruth's demise leave unanswered questions about whether his death was of natural causes or murder. His skull, with large holes in each side, was found about three-quarters of a mile from the rest of his skeleton on December 11, 1931.

Ruth—a slight, bespectacled man of about five feet, five inches, and 120 pounds—immigrated to the United States from Germany. He took out citizenship papers and, by 1880, was living in New York City with his wife, Dalia, and a son, Charles. Whether his wife died or they were divorced is not known, but a year later, he remarried. To this union was born three children: Stella, Erwin and Earl. Ruth tried farming in Missouri and Kansas but failed miserably at these enterprises. While working as a barber in Kansas, Ruth studied and graduated from veterinary school. By 1903, he was employed at the U.S. Department of Agriculture's Bureau of Animal Husbandry. He transferred to Richmond, Virginia, where he performed creditably enough

in government service. With the advent of World War I, Ruth's pro-German sympathies and heavy German accent made him suspect to his fellow workers. However, because of his painstaking reliability, he was retained in his government position. With his meticulous attention to detail, Ruth appeared perfectly suited to the position of a minor bureaucrat. Walking with a limp, Ruth seemed hardly the sort who would go in search of lost treasures; however, he, along with his son Erwin, became interested and collected information on lost mines. Erwin became both a medical doctor and a veterinarian.

By 1913, Erwin was working near Matamoros, Mexico, for Venustiano Carranza, a Mexican Revolution leader. In exchange for getting rid of ticks at the rate of a dollar a head of cattle, Erwin was made a captain in the Mexican army. During this period, he met a man named Juan Gonzalez, who had been thrown in prison for advancing money to the foes of the Carranzistas. He made Erwin an offer. If Erwin would get Gonzalez's wife and widowed daughter out of Mexico, he would give him a set of maps that showed the location of rich gold mines in the United States. Erwin transported the family safely across the border, and Gonzalez gave him the maps. Some of these maps described mines in the Borrego area of California and the Superstition Mountains of Arizona.

Erwin resigned from the Mexican army and headed out to find gold in California. In 1919, Adolph and Erwin visited the Borrego area to check out sites from their maps. Adolph ignored his son's warning about starting out on a search so late in the day. Alone, he headed for a mountain to look for the Lost Pegleg mine. This was the first time Adolph disappeared. When he did not return, Erwin tried to track his father but with no luck. Two days later, he secured help from squatters, and together they discovered that Ruth had fallen into a ravine. He was safe, but had fractured a thighbone and had to be transferred to a hospital in San Diego. There he was operated on and a metal plate was inserted in his leg. The plate later became a factor in identifying Ruth's skeleton. Because he had not been granted leave from his job, Erwin told reporters that his father was a government geologist looking for oil.

Adolph recovered, but his left leg was shorter than his right and caused him pain for the rest of his life. On August 2, 1920, eight months after leaving his employment, Ruth went home, fortunate to still have his job. By now, the gold bug had bitten Ruth, and he was no longer a reliable government bureaucrat. Problems with his leg, inattentiveness and lack of performance forced Ruth into retirement with a small pension. He was happy enough with these conditions and plunged back into his search for lost treasure.

This time, he turned his attention to another small map in the Gonzalez collection. Mrs. Gonzalez, who was living in California, told him that this map had belonged to her husband's cousins the Peraltas. Adolph gave up on the Borrego treasure and decided to search for the Lost Dutchman's gold. In his lost treasure collection, Ruth had an article written by Pierpont C. Bicknell that appeared in the *San Francisco Chronicle* of January 13, 1895. It supposedly described the Lost Dutchman's mine location: "It lies within an imaginary circle whose diameter is not more than five miles and whose center is marked by the Weaver's Needle, a prominent and fantastic pinnacle of volcanic tufa that rises to a height of 2,500 feet."

Bicknell claimed that Jacob Waltz and a partner had followed a trail that led them over a high ridge, past Sombrero Butte into a long canyon running north and then splitting into a tributary canyon. In 1931, over protests from his family, Adolph again set out to discover lost treasure. He lied when he told his family he just wanted to sit on rocks and let the Arizona sun bake the rheumatism out of his bones. In March, he bought an Essex automobile, and found a traveling companion whose name is not known. Together they left Washington, D.C., on May 4. At Apache Junction, the two men parted company; his young companion presumably went on to Washington State to study at a university, and Ruth set his sights on finding gold. He had absolutely no comprehension of the size of the Superstition Mountain area, but even if he had, it probably would not have mattered to him.

He met William Augustus "Tex" Barkley, who owned a ranch, the Quarter Circle U, on the southern fringe of the Superstitions. He had purchased the property from James E. Bark, who coined the name "Lost Dutchman." Barkley gave prospectors room and board in exchange for work and a little money. He believed in the mine's authenticity but knew very well the danger of prospecting in the Superstitions. On May 13, Adolph arrived at the ranch. Two seekers of the Lost Dutchman, Milton Rose and George "Brownie" Holmes were already there. They tolerated Ruth, but he appeared out of place among prospectors in his pinstriped suit. However, he was undaunted and talked freely, maybe a little too freely, about his maps and documents. He said he knew where he was going to find gold, but he needed someone to pack him into the mountains, close to Weaver's Needle. Barkley had no desire to take this frail elderly man into the mountains when the weather was already hot, but Ruth was persistent. Finally, the rancher agreed to act as a guide on one condition: Ruth had to wait until after Barkley returned from taking a herd of cattle to the railroad. Before he left on June 12, Barkley ordered his ranch hands not to take Ruth into the mountains on any condition.

No sooner had Barkley left than Ruth took off with two part-time cowboy prospectors, Leroy F. Purnell and Jack Keenan. He made an agreement with them that if they would pack him into the mountains, then they could use his car while he was prospecting. Also there would be a bonus for them when he found the mine. They agreed, and one of the men purchased his supplies while the other secured his burros. On June 13, the trio, with a couple other men mounted on burros, headed for Willow Spring in West Boulder Canyon. After a rough trail ride, Purnell and Keenan set up Ruth's tent and bed. They promised to return several days later with additional supplies. The temperature was in the mid-nineties. The next day was Sunday. After a good night's sleep, Ruth wrote a letter to his family saying that he was gradually getting his camp shipshape and that the next day, he would start prospecting. It was the last letter he ever wrote. At the same time, Keenan and Purnell had a high time touring around Phoenix in Ruth's automobile.

When Barkley returned to the ranch on June 17 and found Ruth gone, he hit the roof. He ordered Purnell and Keenan to get the old man out of the mountains without delay, but they could not find Ruth. Three days later, Barkley, Purnell, Keenan and several other men formed a search party, but they had no luck either. They notified the sheriff's offices in Phoenix and Florence. On June 25, Pinal County deputy sheriff Chester McGee formed a posse to search for Ruth. That day, his disappearance made national headlines. Spurred by the reward from the Ruth family, trackers, posses, independent investigators and ranchers searched, but by this time, no one expected to find the seventy-seven-year-old man alive. Erwin arrived on June 30 and hired Charles Goldtrap, a local aviator, to fly over the country. There was no sign of Adolph Ruth.

Erwin urged Barkley and former Maricopa County sheriff Jeff Adams to make one last search for his father. They found tissue paper of the type Ruth used to wrap his food, bits of his brown pipe cleaners, the letter and his handkerchief. They found no stone monuments indicating that Ruth had staked a claim. Erwin gave up hope and returned to Washington, D.C.

Several months later, an archaeology team went into the mountains to look for traces of early Native American civilization. George "Brownie" Holmes acted as the guide. On December 11, while the team was trekking out of Needle Canyon, one of the dogs, Music, took off up a rise. The leader of the expedition, Odd S. Halseth, followed the dog to see what had attracted its attention. It was a human skull, which smelled bad and still had pieces of flesh attached to it, as well as large holes on each side. Holmes was certain it was Adolph Ruth, but Halseth insisted the skull was that of an

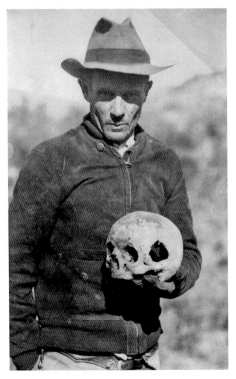

Left: Brownie holds Adolph Ruth's skull. *Courtesy Superstition Mountain Historical Society.*

Below: Maricopa County sheriff Jeff Adams with the dog Music, who discovered Ruth's skull. *Courtesy Superstition Mountain Historical Society.*

ancient Indian. Arguments developed among the expedition members. Three Phoenix doctors examined the skull and agreed that even if it was not Ruth, it was that of an elderly white man. Halseth had run out of research funds and was trying to sell his story to the Science Service Center. When the *Arizona Republic* broke the story that the skull was believed to be that of Adolph Ruth, the center was no longer interested in Halseth's account.

Halseth claimed possession of the skull and sent it to the Smithsonian Institution. Through dental records, it was determined to be Adolph Ruth. Dr. Ales Hrdlicka, curator of physical anthropology at the Smithsonian, announced that it was a recent skull of a white man who had probably been shot. Adams and Barkley went back into the mountains to see if they could find the rest of the skeleton. On January 8, 1932, they found Ruth's skeleton several hundred feet up Black Top Mountain about three-quarters of a mile from the skull location. Most of the bones were located, but it appeared that animals had made off with the hands and feet. Ruth's prospector pick had not been used. His clothing was shredded, but they found his watch, billfold, empty thermos, unfired gun, flashlight and medicine kit. They also found one document, a topographic-survey chart with notations by Ruth. On it, he had written "Veni, Vidi, Vici [I came, I saw, I conquered]." What was missing was his copy of the Peralta-Gonzalez map.

Adams and Barkley, before leaving the mountain, tried for two days to find the Lost Dutchman mine using Ruth's directions on the topographic map. They found nothing. Coroners from Pinal and Maricopa Counties pronounced the cause of Adolph Ruth's death to be exhaustion and heat prostration and said there was no evidence of criminal activity. Ruth might have left the Gonzalez map back at his camp because after many years, he had probably memorized it. Immediate suspects included Purnell and Keenan. They were not arrested, but Barkley was angry that they had taken Ruth into the Superstitions. Keenan and Purnell might have stolen the map, but they evidently did not murder Ruth because they were able to give a full account of their actions after they left him. After the case was closed, Purnell went to Idaho, and Keenan moved back to Oklahoma. Keenan's widow said that her husband and his partner were never able to find the gold mine even with the map.

Some theorized that a murderer shot Ruth, beheaded him and buried the skull with the bullet holes. Others questioned Dr. Hrdlicka's ability to determine whether the holes in the skull were made by bullets. Hrdlicka went so far as to say, "The caliber of the fatal bullet was a .44 or .45, and the shot had been fired from an old army revolver." Others pointed out that that

there were no bullet holes in his hat. He might have taken his hat off. His glasses' frames were undamaged. He might have taken his glasses off. His dentures were intact. He surely did not remove his dentures. The fact remains: there were holes in his skull.

A history of decapitations has been associated with murders in the Superstition Mountains. Elisha Reavis's beheading in 1896 is the first recorded. His remains were found near his house, and his skull was discovered nearby. In 1933, the headless remains of Bernardo Flores were found in the Mazatzal range north of the Superstitions. In 1947, more than a decade after Ruth's death, James A. Cravey, a retired Phoenix photographer, disappeared after being set down in La Barge Canyon by a helicopter. Two hikers found his headless skeleton, and twenty-four hours later his skull was found a few feet away. Those who contend these men died of natural causes or heat prostration believe that mountain lions are the culprits of the beheadings. Perhaps the summer flash floods transported the skull far from the rest of the skeleton. There are just as many reasons to believe that Adolph Ruth was murdered. He would have had to hike five to eight miles in desert heat to get to the point where his skeleton was found. This would have been difficult, if not impossible, for the elderly man. His skull was found about three-quarters of a mile from the skeleton; most of the other skulls were found a few feet from the bodies. If Adolph Ruth was murdered, who did it? Who was the mysterious student driver who took Ruth to Apache Junction?

Walter Gassler retired and hoped to find the Dutchman's gold. *Courtesy Superstition Mountain Historical Society.*

Walter Gassler, a professional chef from California, became intrigued with the Adolph Ruth story and the story of the Lost Dutchman mine. He researched the Jacob Waltz legend in California libraries until he got a job as a pastry chef at the Biltmore Hotel in Phoenix. Before long, he was pitching a tent in the Superstition Mountains, and he became good friends with the rancher Tex Barkley from the Quarter Circle U Ranch. Barkley shared with Gassler stories and sites, including an Indian encampment at Peter's Mesa. Gassler proved to be a serious gold-seeker, and he found the sites that Barkley described, much to the rancher's surprise. Then Gassler left as suddenly as he had arrived. The Superstition Mountains were no place for a new wife. Decades later, Gassler appeared once again to be on a serious search for the Dutchman's gold. He believed that the mine was on Peter's Mesa and decided that a clue was a "rock-that-looks-like-a-man" in La Barge Canyon. Gassler once again set out on a search, but he had not been in the killer mountains for many years; the country had changed or completely disappeared. Moreover, Gassler was now eighty-two years old.

Thoroughly frustrated, he sought the help of other gold-seekers, including Robert Corbin, who had also served as Arizona attorney general, and Tom Kollenborn, who had guided many gold-seekers into the mountains. Neither Kollenborn nor Corbin could get away to help Gassler, who would not wait. When he threatened to take the bus to Apache Junction and walk into the mountains, his wife agreed to drive him to First Water Trail Head. After two more unsuccessful attempts to get Corbin and Kollenborn, on May 2, 1984, Gassler unloaded his pack at First Water and said goodbye to his wife.

On May 4, Don Shade and another guide were riding up Charlebois Ridge when they spotted Gassler apparently sitting on a rock. Shade immediately assumed that he had died, and they rode out and notified the sheriff. Because Gassler had died on the county line, both Pinal and Maricopa County sheriffs became involved. Gassler's body was taken to the Pinal County medical examiner. There was no evidence that he had met with foul play, and Gassler's death was ruled to have been from natural causes, probably a heart attack. Before long, a man showed up, claiming to be Gassler's son, Roland, asking for Gassler's personal effects. He showed Kollenborn some rich gold ore samples that he claimed had come out of Walter's knapsack. Roland insisted that his father had found the Lost Dutchman mine and asked Kollenborn for the manuscript and maps that Gassler had lent him. Kollenborn readily gave him these materials.

Several weeks later, while Kollenborn was giving a presentation on the Superstition Mountains, a man came up and introduced himself as Roland

Gassler. It was not same man who had earlier claimed to be Gassler's son. After Kollenborn checked his identification, it turned out that this was the real Roland Gassler. Just who was the first Roland Gassler and where did his gold come from? The real Roland Gassler claimed that the knapsack had disappeared from the sheriff's inventory. The fake Roland Gassler was never seen again.

4
FLIGHT INTO OBLIVION

The sweltering temperatures and utter desolation of the Yuma desert have spelled death for countless prospectors, explorers, illegal aliens and hikers who enter this unforgiving land without adequate water and supplies. Natural wells are present, but they are hard to find and even more difficult to reach. Klaus Martens and Mary June Walker might have flown into this desolate expanse—and to their deaths—in 1951. On July 31, a Cessna plane was discovered south of Wellton near the High Tanks, or Tinajas Altas, region in Yuma County. Unfortunately, the plane's occupants—pilot Klaus W. Martens, a Pasadena truck salesman, and his companion, Mary June Walker, a nursing student—were never found. To this date, no one knows if the desert claimed their bones or if they deliberately flew into oblivion and took up new identities elsewhere.

Their story started on July 15, 1951, when Martens rented the Cessna 140 airplane with CAA registration N77275 in Los Angeles, presumably for an afternoon flight to Blythe. Whether through forgetfulness or by design, Martens did not file a flight plan. When the couple did not return that evening, authorities were notified. The Civil Air Patrol searched the mountains and desert between Los Angeles and Blythe, but after several hours, the search was abandoned. The Yuma Civil Air Patrol was notified of the missing couple and undertook a search. This group, led by Major Ted McDaniel and Captain Les Harnett, spent a total of forty-eight hours in the air and covered a forty-five-mile radius of Yuma. Their efforts turned up nothing.

On July 25, a Santa Fe Railroad worker reported seeing a flare in the desert near Blythe on the same evening the couple disappeared. The Civil Air Patrol investigated this clue. A squadron of thirty airplanes checked the area around Blythe and the Mexican government gave permission for the U.S. Air Force to continue the search one hundred miles below the border. Once again the search was unproductive. Martens's mother and stepfather, Mr. and Mrs. Fernando Martens, and Mary June's father, John Walker from Malverne, New York, arrived in Riverside, California, to participate in a search. However, there were no more searches until July 31, when three U.S. Fish and Wildlife Service employees—Harry Crandell, John A. Kempton and Clayton Lang—found the couple's airplane. The plane had landed safely about one hundred yards off a dirt road leading to Tacna, thirty-five miles to the north of Tacna, and Tule Well, eighteen miles to the south of Yuma. The site was part of the Williams Field aerial gunnery range. The plane's landing spot was flat desert terrain, covered with volcanic crust so thin that vehicles often broke through it and became mired in the sand.

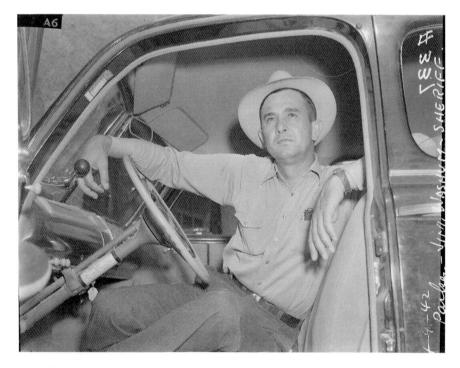

Sheriff Jim Washum directed the ground search for Klaus Martens and Mary June Walker. *NARA Archives.*

When the Yuma County Sheriff's Department was notified, Sheriff Jim Washum launched the largest manhunt in the county's history. Washum, a tough western sheriff, had been elected on his promise to clean up illegal gambling and vice. When Washum's law enforcement personnel arrived, they found a note pinned to the plane seat that read, "5:45 a.m. Monday and we are walking west." The couple had also drawn a large arrow pointing west on the ground near the plane. If Martens and Walker walked west, as they apparently did from the direction of their tracks, they would have gone in the opposite direction from the nearest water and civilization. Inspection of the plane confirmed that it had not gone down because of mechanical difficulties. Officers were able to start it up immediately. The couple left behind a compass, which anyone lost in the desert would have found useful. The plane's radio transmitter and receiver were in perfect working condition and were used by the searchers, yet Martens and Walker apparently never tried to use the radio to call for help. Both wing tank gauges registered empty, but there was still enough fuel to taxi them to the dirt road.

The couple's tracks crossed this road, which would have taken them to Wellton, a little more than thirty miles from the landing site. If they had walked along the road, they most certainly would have met someone who would have rendered aid. Sheriff Washum held out little hope to the family of finding the couple alive in a desert, which often reached temperatures of 120 degrees. However, a new search was started without delay, using paratrooper-carrying planes and experienced ground searchers in Jeeps and four-wheel drive vehicles. About a dozen members of the sheriff's posse rode their horses into the desert. The Civil Air Patrol also participated in this search. Searchers picked up tracks heading west but lost them in a trail that had been washed out by a recent thunderstorm. The ground posse fanned out to search the general westerly course taken by the couple. Officers from March Air Force in Riverside, California, sent a land rescue team to the scene, along with two paratrooper planes, to assist in the search. The couple appeared to have headed for the desolate Fortuna mountain range.

On August 1, Yuma County deputy sheriff Joe McGill told the story of the search and made a plea for information over the radio, which was carried by more than 540 stations across the United States during evening prime time. The next day, there was new hope when searchers found a new set of tracks about twelve miles from the plane. These tracks were lost, but veteran desert prospectors found them again the next morning,

leading farther west. Near the tracks, the large letters *F* and *L* were found traced in the sand. In air search code, *F* means food and water are needed, and *L* means fuel and oil are required. Searchers again probed an ever-widening radius of the area with no luck.

It became increasingly doubtful that the couple could have survived very long, as they could not have picked a worse direction to travel. Their tracks were followed toward the foothills of the Cabeza Prieta Mountains, running parallel to the Camino Diablo, or the Devil's Highway, where many have lost their lives from heat and thirst. At some point, they were within four miles of water at the tanks and wells. The ground crew, especially veteran prospectors, were reluctant to give up the search, and many scoured the desert after dark with flashlights. Sheriff Washum called in his posse on August 2, after heavy rains had obliterated any sign of tracks. During their days off, the crew had a chance to review new information that had been puzzling them. It also gave new hope that the couple, if alive, might have been able to recover some rainwater.

The couple indicated that they had started west, but from the air, Martens must have noticed that only barren desert and mountains lay before them. Why did he choose to ignore the dirt road, which he must have seen from the air and which would have taken them to U.S. Highway 80? It is unusual for lost people to not leave a trail of signs, such as pieces of clothing, remnants of a fire, etc. Nothing was found of the Martens-Walker party along their track trail. One would think that they might have rested in the shade of the plane at some point, yet there was no evidence of any ground disturbance.

By August 5, Sheriff Washum had all but given up any hope of finding the couple. He expressed the opinion that Martens and Walker might have died from heat and thirst and that their bodies were covered by sand brought in with the heavy summer storms. Three days later, the search was abandoned. After he called off the search, Washum had to dispel accusations that he had called the whole thing a hoax and was not doing all he could. In November, Mary June's mother, Elizabeth Walker, said she believed the couple was still alive but that her daughter had not communicated with her because she feared for her life. She did not elaborate about whom Mary June might have feared. Mrs. Walker told the press that there would be a new search and made a trip to San Francisco to learn the name and address of Klaus Martens's biological father in Germany. Her announcement was made a day after someone else told Superior Court judge Newcomb Condee of Pasadena that he

believed Martens was still alive. Roscoe R. Hess, trustee of Martens's affairs, told the judge that suspicious circumstances made it inadvisable for the court to rule Martens legally dead—yet. He did not specify the nature of these circumstances.

On February 18, 1952, a wife of a house painter, Stephen Valko, in New York City telegraphed Arizona authorities that her husband thought he saw Klaus Martens and Mary June Walker on Forty-Second Street. Valko identified the couple from photographs that were run in newspapers across the country with the offer of a $1,000 reward for any knowledge of their whereabouts. Valko said he was stopped by a couple driving a 1949 Ford with Arizona license plates. They asked him for directions to the Roosevelt Hotel and inquired into where the *Queen Mary* was docked. A quick check at the Roosevelt Hotel revealed that no one had registered with an Arizona car.

Hess offered a reward to keep the search alive because there were so many rumors of sightings of the couple in Mexico and Europe. To his credit, he spent a great deal of his own time and money trying to locate the couple. The reward brought out many amateur detectives, who were totally unqualified to investigate the desert locale. Sheriff Washum warned everyone intending to search the area to be very careful because of its proximity to the gunnery range. On July 16, 1953, the *Yuma Daily Sun* received a letter from Harold Debus of Pasadena, who reported his investigations on the couple. It appears that Debus was an attorney, but why he chose to make his findings known through a newspaper instead of going to law enforcement authorities is unclear. His letter read in part:

> *Regarding the girl's disappearance, Mrs. Whalen* [Walker's aunt] *explained that on August* [July] *15, 1951 at about 7:30 a.m. Klaus appeared and asked for Mary June Walker, stating that she was to accompany him on an airplane trip to Blythe. I went to June's bedroom and awakened her. She got dressed, and then I invited both of them to have breakfast. Klaus was very nervous and repeatedly referred to the time saying, "Look Sonny* [Walker's nickname] *if we don't get down there, they will be looking for us."*

Who "they" were was not established in Debus's letter. The couple left Whalen's home at approximately 9:30 a.m. Whalen did not know which airport they were using. She told Debus that she protested to Mary June about the way she was dressed for a desert trip, but Klaus assured

her that they would be back by evening. Walker had met Martens at the Huntington Memorial Hospital, where she was a nursing student and where he had been a patient in February 1951. Martens had a reputation as a lady's man and frequently boasted about his affairs. His former wife had divorced him in April 1951. Ray Woods, sales manager of Orrin Knox Automobile Company in Pasadena, where Martens was employed as a truck salesman, said he knew about Martens's trip to Blythe and described Klaus as a rotten pilot.

Whalen said she had stopped at Ralph's Mills, just east of Yuma on Highway 80, while returning from a trip to the East Coast and was told by someone there that an acquaintance of his had seen a plane circling in the vicinity of the spot where the missing couple's plane had been found. Debus talked to Martens's mother, Mrs. Ferdinand Martens of Berkeley, but she refused to give out any information on Klaus's father, who was supposed to be a baron residing in Germany. She did, however, make a trip to Germany after the couple disappeared.

The younger Martens had a somewhat murky background. While he resided in Pasadena, he became very active in the Junior Chamber of Commerce and gave several talks detailing his experiences in the Nazi Youth Movement. It appears that he came to the United States with his stepfather and mother and took his stepfather's name. Sometime in the late 1930s, Klaus traveled to Germany to visit his father, but about two years later, he returned to the United States after trouble with his father over Nazi discipline.

Martens's boss, Ray Woods, said Klaus was happy over the recent reestablishment of contact with his father. Rumors circulated that Martens still had connections with Nazi organizations that wanted him dead. Others claimed he was part of a free-love cult involving Caltech scientists. Finally, there were those who professed the couple had been captured by an unidentified flying object. Continued reports of sightings of the couple by reliable sources deep in Mexico came into the Yuma County sheriff's office. Some said that they avoided other Americans. The downed plane was actually closer to the border than to the main highway. It is not impossible that they made it to the border, but it would have been very difficult. Three years after the couple's disappearance, Mary June's father, John Walker, a fifty-eight-year-old New York insurance salesman, and his brother Harry arrived in Yuma to see for themselves if two people could disappear "without a trace under such conditions." Walker used his three-week vacation to make the search. The family still

hoped they would at least find the remains of their child. The father began his inspection on April 24, 1954, but it lasted just one day. He sadly told reporters that "faith in our daughter's consideration for her family leads us to believe these rumors [of sightings] are completely without foundation. If June were alive, we are certain she would have contacted us by now."

A sad father realized that he; his brother; and a family friend, Ed Phillips, could not possibly search the entire desert on foot by themselves, and he admitted he had no conception of the desert conditions. "Why you could hide New York City out there and never find it!" He added disconsolately, "I've seen all I care to see. I feel that they are dead somewhere on the desert, but I realize the futility of any search I might make."

Missing bodies are naturally unacceptable, and some linked Martens's history with foreign conspiracy, speculating that his disappearance was part of a plot to leave the impression that he was dead. Thomas Newman took over as Yuma County sheriff in 1956. In June of that year, a partial skull was found by Joe Rogers in the area where Martens and Walker had disappeared. Rogers, who lived in La Mesa, California, and was an employee of the state marshal's office in El Cajon, turned it over to Newman. Laboratory examination showed it to be a female between the ages of twenty-three and twenty-six years old. The skull was found near a wash where it might have been buried under sand for some time. Newman arranged for a posse to explore the area as soon as Rogers could come back to Yuma. The seventeen-man posse in Jeeps and dune buggies set out on October 28. Joe Rider of Roll, Arizona, who was with Rogers when the skull was found, served as a guide for the crew. Newman had only the top of the skull, and he hoped that jaw bones would be found so a positive dental identification could be made.

Searchers found additional human bones near the Mohawk Mountains, but unfortunately, a complete skeleton could not be recovered. These bones appeared to be those of a person older than the person to whom the skull belonged. This ended the last organized search for the couple. The final legal chapter was written in 1959, when Klaus Martens was declared legally dead by his attorney, Roscoe R. Hess. Martens's mother received $3,000 in life insurance. It was an unsatisfactory ending. Why did Martens not use the radio to call for help when it was in perfect working condition? Why didn't Martens taxi the plane to the dirt road when he

had enough fuel to do so? Why was there no evidence of any activity of the couple near the plane? It was as if Klaus Martens and Mary June Walker deliberately got out of the plane and walked into oblivion.

5
THE WHAM PAYMASTER ROBBERY

It should come as no surprise that the U.S. government is short $28,345.10. Events leading to this particular shortage still provoke considerable argument in Arizona. On May 11, 1889, at Cedar Springs, about fifteen miles northwest of Pima, Arizona, one of the most controversial and still unsolved robberies was perpetrated. The entire military payroll in $5.00, $10.00 and $20.00 gold pieces, along with silver quarters, nickels, dimes and cent pieces, for soldiers at two army posts was stolen from a stage after a gun battle disabled the military escort. Paymaster Major Joseph Washington Wham and his men estimated the number of masked robbers to be anywhere from eight to twenty-one. They also believed that they killed one of the robbers, but no corpse was ever found.

Joseph Washington Wham, born in Illinois in 1840, served as an enlisted man with the Illinois Infantry until 1865, when he was promoted to lieutenant. In January 1871, he was appointed by President Ulysses S. Grant to the rank of major and paymaster for the U.S. Army. Wham had served as a private in the same regiment in which Grant had been a colonel. Before coming to the Arizona Territory, Wham had been robbed twice while serving as army paymaster and this put him under a cloud of suspicion. He has been called dishonest, incompetent, cowardly and a victim of bad luck.

Wham met the train at Willcox, took his payroll from the express car and loaded it onto the wagon. On that fateful day, he was proceeding from Fort Grant to Fort Thomas and to San Carlos in a government conveyance, with an escort guard commanded by Sergeant Benjamin Brown, from Company

Isaiah Mays with his Medal of Honor, which was awarded for his bravery during the Wham paymaster robbery. *Courtesy Arizona Historical Society.*

C, Twenty-Fourth Infantry. This all-black escort included Sergeant Benjamin Brown; Corporal Isaiah Mays; and Privates George Arrington, Benjamin Burge, Oscar Fox, Thornton Ham, Julius Harrison, George Short, James Wheeler, Squire Williams and James Young. The Congressional Medal of Honor is the highest military award the United States bestows upon individuals for heroism. The two black Americans to qualify for the medal in the 1880s were Sergeant Benjamin Brown and Corporal Isaiah Mays of the Twenty-Fourth Infantry. They were decorated for "gallantry and meritorious conduct" while serving with a detachment defending Major Joseph W. Wham, U.S. Army paymaster, during an armed robbery.

Brown, a native of Spotsylvania County, Virginia, fought the entire time from open ground. Although shot in the abdomen, he did not leave the field until he had been wounded in both arms. Mays, born at Carters Bridge, Virginia, without the knowledge of Major Wham, walked and crawled to a ranch to give the alarm. Mays had joined the army in 1881 at age twenty-three. After his discharge in 1893, he worked as a laborer in Arizona and New Mexico. In 1922, he unsuccessfully attempted to obtain a pension with the assistance of Congressman Carl Hayden of Arizona. Mays died at the insane asylum in Phoenix.

Wham had already paid the soldiers at Fort Grant. From Fort Grant to Fort Thomas, the military traveled over a rugged forty-six-mile trail through a narrow canyon at Cedar Springs. Fort Thomas has been described as one of the worst military posts in Arizona because of widespread malaria and an aggregation of saloons, gamblers, loose women and outlaws at the nearby settlement of Maxey. Wham; his clerk, William T. Gibbon; driver Private Caldwell; two noncommissioned officers; and nine privates were transporting the payroll. Nine of the men had shotguns and rifles, and two had revolvers; however, Wham, Gibbon and Caldwell were unarmed. The escort rode in a conveyance known as a Dougherty wagon, which was specially prepared for paymaster duty. Benches lined each side of the wagon with five men to the side facing one another and one man on the driver's seat, permitting a wide view of the passing countryside. Wham, Brown and Caldwell traveled in a separate wagon with the gold in Treasury Department sacks.

Shortly after passing Cedar Springs, the group came to a point in the canyon where the road was blocked by a large boulder. With no room to pass, the escort got off the wagon and walked forward to remove the rock, leaving weapons behind. While struggling with the rock, the soldiers were fired on, and several of the escorts were wounded, including Sergeant Benjamin Brown, who was shot in the stomach. Burge was shot through a leg and both hands. Ham and Wheeler were each shot in an arm. Arrington was shot in the shoulder. Harrison was shot in an ear. Williams was shot through both legs. Wham and his men ran to get out of range of the concealed bandits. After the soldiers retreated, the robbers came out of their hiding spots, broke the trunk open with an axe, took the money and disappeared into the mountains. Wham later testified: "The shots came from the opposite side of the road; there were a number of shots also fired from the right, also from the left in the direction of Fort Thomas; the men who fired on us were protected by artificial and natural forts, built by constructing wings on either side of large rocks on the hill."

Barney Norton, a rancher who lived about three miles southeast of Cedar Creek, heard the gunshots and after the shooting stopped, he gathered his men and went to render aid to the paymaster. By this time, the robbers had disappeared. Norton sent a courier to Fort Thomas for help. Captain Thomas C. Lebo, commanding officer of Fort Thomas, dispatched a surgeon and wagons to bring in the wounded. Lieutenant Powhattan H. Clarke, with several soldiers, attempted to pursue the robbers. Territorial governor Lewis Wolfley offered a reward of $500 for each robber, which was matched by U.S. marshal William K. Meade. Within a few days, the site was swarming with soldiers, detectives and scouting parties, but the trail had gone cold. The Fort Thomas soldiers were especially unhappy because they got paid only once a year, and now they did not even get that. They held Wham responsible.

There were many accusations that Wham had acted in a cowardly manner. Frankie Campbell, a black woman, was following the train so she could set up a gambling game and collect outstanding debts after the soldiers were paid. She testified, "Lord he run so fast, you could of played checkers on his coat tails." One of the first persons to be arrested by Meade was Frankie Campbell on suspicion of implication in the crime. However, she had rendered aid to the wounded and became a star witness for the prosecution when she provided names. With her testimony, it was hoped the baffling crime would soon be solved and the gold retrieved.

Strong resentment of Mormons in Arizona prevailed at this time, and many still feel that the arrest and indictments on June 12, 1889, of prominent Mormon farmers Lyman Follett, David Rogers, Thomas Lamb, Warren Follett, Wilfred T. Webb and Gilbert Webb was done out of prejudice. Gilbert Webb was the brother of Ann Eliza Webb Young, the twenty-seventh wife of Brigham Young and the only wife who divorced him. Wilfred Taft Webb, the son of Gilbert, later served as Speaker of the House of Representatives of Arizona Territory and served as a member of Arizona's Constitutional Convention. He cast Arizona's first electoral vote in 1912. Dave Rogers is reputed to have owned the first automobile in Pima, Arizona. The Folletts were the grandsons of King Follett, at whose funeral Joseph Smith preached a famous sermon, "The King Follett Discourse." Marcus Cunningham was the only non-Mormon charged with the robbery. Several others were arrested, but only these men stood trial. Judge Richard Sloan, who presided at the trial, believed that they got the right men but not the right verdict.

Mark E. Cunningham and William Ellison Beck, aka Cyclone Bill, were arrested on the basis of Campbell's testimony. Cyclone Bill liked to be thought of as a bad man but was really quite amiable except when

The Wham paymaster defendants and their attorneys posed for a picture. *Counter clockwise from front*: Marcus A. Smith, attorney; Ben Goodrich, attorney; Gilbert Webb; Ben Hereford, attorney; Frank Hereford, attorney; Wilfred Webb; Walt Follett; Thomas Lamb; David Rogers; Joseph Follett; Lyman Follett; and Marcus Cunningham. *Courtesy Arizona Historical Society.*

drinking. Thornton Ham testified that according to his "knowledge and belief," Cyclone Bill was one of the robbers. James Young corroborated Ham's testimony and added that he saw Beck shooting at the soldiers. Both Beck and Cunningham were released for lack of evidence. Cunningham was later rearrested.

By May 27, there had been a rash of arrests. They included Lyman Follett, who had a hard time explaining a wounded hand. Jack Reed testified that Follett had showed up at the roundup about a week after the robbery with a bandaged hand, which was treated by the Dr. William Thomas at Fort Thomas. W.O. Tuttle and Louis Voeckel of Fort Thomas were arrested but discharged. Gilbert Webb, Wilfred T. Webb and Siebert B. Henderson were in jail by June 5. On September 21, 1889, the grand jury investigation opened under U.S. commissioner Louis C. Hughes. Wham identified Gilbert Webb and Warren Follett as two of the men who had robbed him. Private Burge corroborated his testimony. In addition, Burge identified Mark Cunningham as being present at the holdup. Frankie Campbell also identified Gilbert

Webb and Thomas Lamb. Those indicted by the grand jury were lodged in the Pima County jail at Tucson. The Mormon citizens of Graham County were indignant over the alleged shake down. One writer commented: "If there are any people in the Valley who have not been arrested for complicity in the robbery of Paymaster Wham they had better roost high, as another $500.00 reward has been added to the amount already offered making it $1500.00 per capita."

After the initial hearings, the men were released on bond. During the summer, investigations continued. Henry Fowler, a rancher from Pima, and Robert Nichols were arrested by Deputy Sheriff Jim Parks as accessories to the crime and were taken to Tucson for questioning, but they were released for lack of evidence. Charges and countercharges flew back and forth with both sides accusing each other of tampering with the grand jury. District Attorney Harry Jeffords charged Joseph Follett with trying to get Henry Fowler to withhold testimony that he had found money in his haystack, which was claimed by Gilbert Webb. Benjamin Crawford, who had previously served as Graham County sheriff, was indicted for jury tampering. Testimony was taken that Thomas Durand claimed that Marshal Meade wanted him in town for the trial, preferably as a foreman of the jury. Durand was anxious to comply because he wanted to get even with the "damned Mormons" because of what some Mormons had done to his friends in Utah. Meade was also accused of browbeating, frightening and intimidating persons who were sympathetic to the defendants. Heber Cluff testified that U.S. deputy marshal C.F. Dunnavan threatened him if he did not deliver Gilbert Webb. Cluff served as one of the bondsmen for Webb. Robert Ferrin was indicted for having perjured himself by saying he had seen Lamb on the day of the robbery when he had not. The grand jury got tired of these shenanigans and sent a telegram to Washington requesting a new judge to replace W.C. Barnes, who had lowered Gilbert Webb's bail from $15,000 to $10,000. Part of the letter to U.S. attorney general H.W. Miller read:

> *While in the midst of our investigations, and while the suspected robbers and their relatives and friends are endeavoring to corruptly influence the government's witnesses to withhold their testimony from this grand jury, one of them having already been indicted for this offense, the judge of this district from the bench this morning, on a motion to perfect the bail of the principal defendant in the presence of the government's witnesses, and a crowded courtroom, made some strong remarks evincing strong feeling between the court and the officers and witnesses. The result of the judge's*

remarks and manner will be the demoralization of the government witnesses soon to appear before the grand jury.

When Judge Barnes learned of the missive, he summarily dismissed the grand jury on September 30, with scathing words pointing out that what the court did in the matter of bail was not the jury's concern. However, because a new presidential administration had come in, he was removed and replaced by Richard C. Sloan. A new grand jury was "grinding the matter down so it could be handled with more rapidity." It produced indictments, and the trial was ready to proceed.

Because this was a federal case, the trial was held at federal court in Tucson. The town did a boom business with the notoriety of the grand jury hearing. Visitors and witnesses required food and lodging. Finally, a jury was empanelled to the satisfaction of the prosecution and the defense. The case came to trial in November 1889; lawyers for the prosecution included William Herring, U.S. attorney Harry R. Jeffords and Selim M. Franklin. Defense counsel included Ben Goodrich; Marcus A. Smith; Frank Hereford; and his father, Ben Hereford. Lyman Follett, David M. Rogers, Thomas N. Lamb, Warren Follett, Wilfred T. Webb, Gilbert Webb and Mark Cunningham were the defendants. In a brilliant legal move, Marcus A. Smith insisted that the men be tried as a group so that all would be found either innocent or guilty.

The prosecution called Major Wham as the first witness. He said he had the twenty-, ten- and five-dollar gold pieces and various denominations of silver in sacks furnished by the Treasury Department in the boot of the stage. He testified that the robbery occurred in a high gorge with high ledges of rock on either side. Private Caldwell rode on the front seat of the conveyance with Wham and his clerk, W.T. Gibbon, on the rear seat. When they stopped to investigate the boulder in the road, volleys of fifteen or twenty shots were fired from several directions. The soldiers tried to defend the stage, but they were wounded and outgunned. Wham said, "I first saw Gilbert Webb; think I saw David Rogers. I found all the escort but four wounded and behind a bunch of mesquite brush; was then in a helpless condition to make a fight. It was about 3 o'clock when I returned to the ambulance after the fight."

Wham also said that the robbers had left a trail of blood near where they broke open Wham's personal trunk, leading the soldiers to think they had killed one of the highwaymen. Unfortunately for the prosecution, most of the witnesses were African Americans, and at that time, their testimony was not taken seriously. At the same time, Arizona residents felt that federal cases

were over prosecuted, and they were miffed at being rejected for statehood. They were in no mood to do the government's bidding.

During the trial, Frankie Campbell positively identified Thomas Lamb, Wilfred T. Webb and Gilbert Webb in the courtroom. She had volunteered to stay with Brown until help came. When the defense counsel asked why she could not identify more of the robbers, she replied, much to the amusement of the prosecution, that she did not think he could have identified anyone under such circumstances.

Sergeant Brown, a crack shot, standing third in the Pacific Coast rifle division, positively identified Gilbert and Wilfred Webb and Mark Cunningham. He heard the robbers shout: "Git back you black so an' so's"—and they got. The major and some of the soldiers hid behind the rocks and then ran down the hill and got behind more rocks. Private George Arrington, who identified Gilbert Webb as one of the bandits, completely lost the use of his arm from his wound during this battle and was about to be discharged. Private George H. Short saw Wilfred Webb and Mark Cunningham shooting and emptying his six-shooter on them. He had known Cunningham in Fort Thomas and was able to make a positive identification. Corporal Isaiah Mays identified Warren and Lyman Follett and Wilfred Webb. He had known Lyman for about six months. Private Burge identified Wilfred Webb, David Rogers and Mark Cunningham. When the defense counsel tried to discredit Burge's testimony, he coolly responded, "I'm used to being under fire. I have been in three engagements with the Indians, two in Mexico and one in the panhandle of Texas."

Henry Fowler testified that on the night of the robbery, Mark Cunningham had eaten supper with his family and then slept near Fowler's haystack. A few days later, Gilbert and Milo Webb came to the Fowler ranch and said Cunningham had left something in the haystack. Fowler said they dug up a sack full of silver, and then Gilbert Webb gave him twenty-five dollars to burn the government canvas sacks.

Gilbert Webb testified, "I was hunting horses that day and was not armed; never carry a shotgun or rifle and seldom carry a pistol." He said he knew nothing about any money in the haystack or government canvas sacks. At the end of the first day, the *Tucson Citizen* reported that the "jury will go to the opera house tonight. They deserve this recreation."

The next day, Carl Hydahl claimed that he had seen Cunningham at Maxey about a month earlier. When the men complained about times being dull, Cunningham asked when the military paymaster would arrive. Hydahl

said it would probably be after the eighth of May and before the fifteenth. Cunningham pumped him for information as to the size of the escort and the amount of money carried on the stage. A host of witnesses swore that the defendants were nowhere near the site of the robbery on that day. Then came testimony that caused a serious rift among the Mormons. Stake president Christopher Layton testified that Webb had recently paid debts to him and several others in gold coins. John Holliday said Webb appeared short of cash before the robbery but paid him twenty dollars in gold afterward.

Webb, when recalled to the witness stand, explained that he had received money from the sale of cattle, payment from an estate and $400 from a son who taught school and had money in a bank in Tucson. One of the prosecutors asked Webb about the gold pieces he was reported to have flashed in a Tucson gambling house. Webb denied the allegations of ever being present in a saloon. Damaging testimony came from other Mormons Charles Allen, Lorenzo Watson and Bishop John Taylor, who claimed that they had gone to Gilbert Webb's house on May 11, but he was not there. Bishop Taylor said Gilbert Webb borrowed a saddle from him a few days before the robbery. When Taylor went to Webb's place to retrieve the saddle on the day of the robbery, Webb was not at home. Allen and Watson, who had also gone to Webb's place, confirmed that he was not at home on the day of the robbery. Hiram Weech said Webb had an appointment with him that day but did not show up. Others testified that Webb was not on the roundup as he claimed.

Defense counsel Marcus Smith rose to the challenge and said he had heard Wham brag that he could identify the gold that had been stolen and was willing to let him prove it in court. In a flourish, Smith spread over two hundred dollars in gold pieces on the table, including money Webb had given him in partial payment for his services. Wham was forced to admit he could not tell one gold piece from another.

The prosecution moved to have this action stricken from the records, and this was granted. However, Smith held the floor for two hours, denouncing the court's rejection of this testimony. Judge Sloan charged Smith with disorder, and Smith retorted that the wrong application was made of his statement. Sloan then cited him for contempt, and Marcus retracted his unfavorable statement. But the action was firmly implanted in the collective minds of the jury members. Finally, the defense called William Edwardy as a witness. Edwardy, who lived in San Francisco, was asked to investigate the robbery on orders of General Nelson Miles. He interviewed several soldiers at Fort Thomas who said they could not identify any of the attackers from

the robbery. Subsequently, several members of the military escort, including Brown and Burge, were recalled. They said they had been instructed by their commanding officer not to tell Edwardy anything, so they said they did not know who attacked them.

Edwardy said he found several dummy guns set up along the road to make it look like there were more robbers than there were. He told the court that he had not felt it necessary to interview Major Wham. Edwardy's real purpose in the robbery investigation was never ascertained, but it appears that he was a writer and had no connection with the military.

Jere Taylor, a witness for the defense, claimed that a prosecution witness, Al Young, threatened to "beat his whole head off" if Taylor tried to discredit his testimony. In his final statement to the jury, U.S. attorney Harry Jeffords pointed out that several members of the Mormon Church had testified against the defendants in order that the criminals might be brought to justice. He paid U.S. marshal Meade and his men high praise for their work in apprehending the criminals.

After the concluding arguments, Judge Sloan instructed the jury that the defendants were not by law required to show their whereabouts at the time of the crime. The burden of proof was on the government. He also instructed the jury that if there was a reasonable doubt of the defendants' guilt, they had to acquit them. After about two hours, part of which time was spent at lunch, the jury returned. On December 14, 1889, Judge Sloan read their verdict, "We, the jurors find the defendants NOT guilty."

Bishop Taylor congratulated Webb, who said, "So you're my friend today, Bishop. Sure couldn't have told you were on my side before the acquittal." The bishop replied, "Neighbor, I hated to testify against you, all of us did, but we only told things as we saw them. Why did you feel it necessary to stretch the truth, Brother?" Jeffords's report to the attorney general in Washington was a scathing indictment of Arizona justice. It read in part: "Vigorous steps should be taken to bring to justice these persons who did testify falsely, and whose testimonies helped to bring about the acquittal of the undoubted robbers, to the end that justice may not be prostituted by the suborning of witnesses in every case where the government is concerned."

Marcus Aurelius Smith came under severe criticism for handling the defense in the Wham Paymaster Robbery. The *Arizona Miner* said it was unethical for Smith, while serving as a delegate to Congress and being paid $5,000 a year, to defend men accused of robbing the government. The *Arizona Republican* ran a picture of Smith with the defendants, asking

"Which is Mark Smith and which are the Wham robbers?" The *Tucson Citizen* commented, "The people are not such condemned lunatics as you think, Mark." Many believed that all the defendants except one turned over the gold to Smith. The case did not seem to hurt his career because he was returned to office with a smash victory in 1890.

Jury instructions also played a part in the verdict. The jury was required to find all of defendants guilty in order to convict and they could not agree that all eight were involved and thus had to return a not guilty verdict. U.S. attorney Jeffords became seriously ill shortly after the trial and died several months later. Major Wham was held responsible for the lost funds but was relieved of this debt on January 21, 1891, when Congress passed an act relieving him of responsibility. Smith, who had ignored his duties as territorial delegate to take the case, was attacked politically for his involvement. Most of the blame for the failed prosecution fell on U.S. marshal Meade. Meade was replaced as U.S. marshal on March 4, 1890. His successor, Robert H. "Bob" Paul, hoped the $500 reward offered by the Department of Justice at the urging of the War Department would lead to a resolution of the case. In August 1892, the Department of Justice asked the U.S. attorney general to investigate charges that the jury had been bribed during the Wham trial, but nothing came of the investigation.

In recognition for their actions during the robbery, Sergeant Benjamin Brown and Corporal Isaiah Mays were awarded the Medal of Honor. Privates George Arrington, Benjamin Burge, Julius Harrington, Hamilton Lewis, Squire Williams, Jason Young, Thorton Hams and Jason Wheeler were each awarded a Certificate of Merit.

In May 1890, three of the accused—Mark E. Cunningham, Lyman Follett and Warren Follett—were arrested by Graham County officials on charges of cattle rustling. They were convicted and sentenced to two years in prison. A conviction appeal reached the Arizona Territorial Supreme Court, which granted them a new trial, but the prosecution dropped the charges before the second trial convened. Gilbert and Wilfred Webb were accused of defrauding the Graham County school district. Wilfred Webb survived the accusations and later became active in territorial politics, serving as Speaker of the House during the twenty-third Arizona Territorial legislature and as a member of Arizona's constitutional convention. When asked if he was involved in the robbery, he would respond, "Twelve good men said I wasn't."

What is known is that a fortune in gold has never been found. In 1937, a chest was given to the Arizona Historical Society that was supposed to have

been the one used in the Wham Paymaster Robbery. Wilfred T. Webb wrote to the society, saying, "I won't deny or affirm that I was one of those in on the Wham robbery back in 1889, but I know that chest isn't the one that figured in the robbery."

6
HALLELUJAH! AIMEE'S BACK!

Never had Douglas, Arizona, seen such excitement as in 1926, when the famous evangelist Aimee Semple McPherson was brought into town from neighboring Agua Prieta, Mexico, after being reported as missing for five weeks. She had last been seen on May 18 while taking a swim near Los Angeles. Presuming that she was dead, her mother staged a memorial service commemorating her death, but there was Aimee in Douglas's Calumet and Arizona Hospital claiming she had been kidnapped by two people named Steve and Rose.

Born on October 9, 1890, on a Canadian farm to Minnie Pierce Kennedy, a Salvation Army lassie, and Robert Kennedy, a somewhat indifferent Methodist, Aimee converted at age seventeen to an extreme form of Holy Roller Pentecostalism that espoused the dramatic laying on of hands and speaking in tongues. After marrying Robert Semple, a preacher of this faith, Aimee moved with him to China to serve as a missionary. In China, her first child, Roberta, was born and her husband, Robert, died within a year. She returned to the United States and married Harold S. McPherson, a grocery clerk. To this union, which eventually ended in divorce, was born Rolf, who followed in his mother's ministerial footsteps.

Aimee began preaching to the country folk of Canada, and before long, her ability to sway crowds brought national recognition. She took her evangelistic success to the United States, but her husband soon tired of her eternal preaching. The final straw came when she took off without leaving him a train ticket or enough money to get to the next stop. Living

Aimee Semple McPherson, a famous preacher, disappeared for about five weeks before turning up in Arizona. *Courtesy Los Angeles City Historical Society.*

from hand to mouth, sleeping in broken down automobiles, preaching in leaky tents, Aimee stormed the gates of heaven—or hell, depending on your point of view—and came to the forefront in the ranks of evangelists. Because Aimee had no head for finances, her mother, Minnie, joined her as a business manager. Aimee arrived in Los Angeles with ten dollars and a tambourine. Four years later, in 1923, she dedicated the mortgage-free Angelus Temple, which seated over five thousand worshippers. Angelus Temple distributed food, clothing and rent money to any of the needy who entered its chambers, twenty-four hours a day. Before long, Aimee's raspy Canadian voice was heard around the country over her own radio station. Shepherds of less boisterous flocks criticized Aimee's flamboyance, but the crowds loved her publicity stunts, her piles of thick brown hair, her expensive clothes and her dramatization of sermons. When she got a speeding ticket, she dressed in a policeman's uniform and rode a motorcycle onto her pulpit, where she preached a sermon on breaking God's law. There was not much Aimee would not do to attract a crowd.

On May 18, she went for a routine swim at Lick Pier on Los Angeles beach and no one saw her come out. The last person to have seen her alive was her devoted secretary, Emma Schaffer. Schaffer could give little information on the disappearance because she went into a state of shock. That Aimee Semple McPherson should disappear was news enough. However, that such a famous evangelist, who was known to be an excellent swimmer, should

vanish under her secretary's vigil, within sight of hundreds of persons along the beachfront, without a cry for help or an apparent struggle in the water, on a calm smooth sea in the middle of an afternoon made banner headlines. When her mother received the news, Minnie's first words were, "Drowned! I think our little sister is gone." She ordered Aimee's belongings and expensive Kissel car returned to the temple. During the next five weeks, everyone held on to a thread of hope that Aimee would be found alive—everyone except her mother, who insisted that she was dead. Already there were whispers that it seemed strange that a mother would not keep hope until at least a body was found.

For weeks, thousands of Aimee watchers gazed at the ocean. Hucksters sold postcards depicting Aimee rising from the sea. Law enforcement was kept busy stopping many of her followers from trying to follow her into the ocean. They were also afraid that if Aimee's corpse were found, souvenir seekers might tear the body to pieces. Her mother adamantly told the congregation, "Aimee is dead" and began collecting funds for a memorial service. Inevitably, there were rumors of murder. However, the only enemies Aimee had were the "dance hall crowd" and Reverend Bob Shuler of Trinity Methodist Episcopal Church, both rather unlikely suspects. There were sightings; Aimee was seen all over the United States, Canada and Mexico. On the fourth day of her disappearance, a judge of the Superior Court, Carlos S. Hardy, denounced rumors that Aimee had disappeared voluntarily over the temple radio.

On May 24, a ransom note signed the "Revengers" arrived at the temple. It asked for a half million dollars in currency and said Aimee had injured them and would have to pay in money or blood. Two police detectives wearing temple badges took packets of what looked like money bundles and waited in the designated Palace Hotel lobby on the designated date. No one ever showed up to collect the money.

At this point, Los Angeles district attorney Asa Keyes entered the case and announced that unless a body was produced within twenty-four hours, he intended to conduct a full-scale investigation. Two of the first people he would question were Emma Schaffer and Kenneth G. Ormiston. Schaffer, always in a nervous state of tears, could not answer his questions coherently. Ormiston had formerly been a radio editor for Temple Angelus. It was rumored that Ormiston's wife, who was about to file for divorce, would name Aimee as the other woman. Ormiston was nowhere to be found. The *Sacramento Union* was the first newspaper to openly express doubt in Aimee's demise. It claimed that people had seen her with Ormiston.

On May 31, Long Beach detective Captain Worley received a call from a blind attorney, R.A. McKinley, a distant cousin of the twenty-fifth president. He said that he had been approached by two men who called themselves Miller and Wilson. They wanted McKinley to act as a go between because he would not be able to recognize them and to secure ransom payment in the amount of $25,000 from Aimee's mother. Mrs. Kennedy snorted at the idea, still insisting her daughter was dead, but she did give McKinley a list of questions that only Aimee could answer. She also offered a $25,000 reward for any information on Aimee. Miller and Wilson never came back.

On June 19, Minnie Kennedy received what came to be known as the "Avengers" ransom note. It had been mailed from a train somewhere between El Paso, Texas, and Tucson, Arizona. This note renewed the demand for a half million dollars and remarked that Aimee's middle right hand finger had a scar, which was true. They offered to send the finger if Minnie needed further convincing. As if the case were not baffling enough, two out of the four answers to the questions given to McKinley came back correctly answered, along with a reddish brown lock of hair, though there was no DNA testing in those days.

Minnie refused to divulge the contents of this note to the worshippers and would have withheld it from the police if she could have. On June 20, she put on a splendid memorial service for Aimee Semple McPherson. Thousands of people had pledged thousands of dollars to the memorial fund. Two days later, Minnie received a call from Aimee in Douglas, Arizona. Now what on earth was she going to do with all that money? If only Aimee had come back a few days earlier.

It had been a hot day for Frederick Schansel, custodian of the slaughterhouse just outside Agua Prieta, Sonora, just across the Arizona-Mexico border. That evening, he stripped down to his underwear and fell asleep. Around midnight, the dogs started barking, and Schansel went to investigate. He found at his door a woman who wanted to use a telephone. When he asked who she was, she replied imperiously, "The whole world knows who I am." He didn't, but he asked her to come in. The woman apparently didn't like the idea of Schansel in his BVDs. She asked if there were any other women in the house. Schansel told her no, but he offered to get dressed. When he came out the second time, the woman had left and was making her way toward town. Schansel went back to sleep, never dreaming that he and his underwear would have their moment in the international limelight.

The woman passed several houses before she stopped at the home of Ramón and Teresa Gonzalez. Ramón was Agua Prieta's mayor and owner

of a bar. He heard a woman calling at the gate. By the time the couple got to her, she had collapsed. Gonzalez was afraid she was dead. While Teresa covered the limp body with a blanket, Ramón ran across the street to get Ernesto Boubion, president of the local municipality, but he was not home. When Ramón returned, he saw with relief that the woman's eyes were open. Meanwhile, Boubion came over, and the men decided they had better get an interpreter.

The American bartender refused to come so long as he had paying customers. This was during Prohibition, and scads of money were to be made by selling booze across the United States border. He advised them to get Johnny Anderson, the taxi driver, who carried tourists back and forth across the border. After a brief conversation with the woman, Johnny informed the Mexicans that the woman claimed to be Aimee Semple McPherson of Los Angeles, who was supposed to have drowned several weeks ago. Aimee told Anderson that she had been kidnapped and had escaped somewhere around noon the day before and made her way to Agua Prieta. If this were true, she wandered around the desert for at least fourteen hours. Boubion instructed the cab driver to take her to the Douglas police across the border. Boubion had questions. Had the woman drunk any water? "Two glasses," replied Teresa. Only two glasses?

At 3:45 on the morning of June 23, George W. Cook, a truant officer and special policeman, was on duty at the Douglas police station, where Anderson brought Aimee in. The woman seemed to be speaking the truth, and he instructed Anderson to take her to the Calumet & Arizona Hospital.

At the hospital, nurse Margaret Attaway helped Aimee undress and put her to bed. Cook apologized, but he had to ask Aimee to blow so he could smell her breath. There was no sign of liquor. Aimee's clothing was taken away. Cook noticed red welts on her wrists, where she said she had been tied by ropes. A slaughterhouse, a man in his underwear, a bartender who refused to stop serving for her, a check for alcohol—none of this portended an auspicious kickoff for a resurrection. Aimee would take care of that.

She had a few cactus thorns and blisters, but other than that, she was in remarkably great shape for having tramped through the desert for fourteen hours. She had no sunburn, no parched lips, no swollen tongue and no dehydration. It was truly a miracle. Chief of Police Percy Bowden—along with several officers and William McCafferty, editor of the *Douglas Daily Dispatch*—arrived at the hospital. A call was put through to her mother, and her identity was confirmed. Reporters converged on Douglas by chartered airplane, train and car. Aimee was in her glory. She

insisted that reporters be allowed in and that she be allowed to tell her story without interruption.

> *I had a particularly strenuous day Sunday, May 16. So Tuesday I went to the beach to take a dip with my secretary, Miss Emma Schaffer, who is a little older than I. I wore a dress over my bathing suit on the way to the beach for being an evangelist I knew I had to be rather careful about those things. When we arrived at the beach I thought of some details concerning our meetings and I asked Miss Schaffer to attend to the like. While she was away I decided to take a dip and walked into the water, waist deep. Suddenly I heard my name called by someone on the beach. I was annoyed at being disturbed. I saw a woman and a man standing on the beach. They began crying and told me that their baby was dying and they wanted me to pray for it. The woman ran on ahead, after giving me a long coat to wear, which she had conveniently at hand. "Hurry," the woman said, "for my baby will die." The woman had been holding what seemed to be a baby, but it turned out to be a bundle of clothing, which she clapped over me and made me smell something which I later found to be chloroform.*

Aimee said that all this had happened around the middle of the afternoon, as nearly as she could judge. She claimed to have awoken in a bed at the dawn of the next day. Aimee thought she was in Mexicali or near San Diego, from what she could catch of the conversation by the people around her. She felt very sick to her stomach. Three persons were in the house, one was a woman they called Rose, who had black hair, dark brown eyes, full lips and weighed about 185 to 190 pounds and who seemed to have been a nurse. One of the men was Steve, a rather heavyset man but not fat, clean shaven, with brown hair and wearing a brown suit. Steve and Rose told Aimee that they wanted a $500,000 ransom for her. When Aimee told them she did not have that much money, they answered, "Pshaw, you have got millions." She claimed they kept her in that room for about four days. Then they moved her by car to another place during the night, and they reached the place in Sonora the next morning. This time, she was placed in a room with very little furniture. There were two cots, one for Rose and the other for Aimee. The men slept in another part of the house, and their conduct toward Aimee was very respectful, except that one of them burned her fingers with a cigar while trying to get some information.

Aimee said she escaped while the couple was gone. When she found a tin can with a jagged lid edge was on the floor, she rolled off her cot, and

managed to cut the ropes around her wrists on the sharp tin. Then she untied her ankles, climbed out of the window and made her way to Agua Prieta. Over and over, she told the same story to the waves of reporters and police who marched into her room. Douglas was thrilled. They drenched Aimee's room with flowers and someone sent her a white silk nightie with a pink silk robe. The nurse lent Aimee her curling iron so she could curl her auburn tresses. Aimee partook heartily of a breakfast of poached eggs, oatmeal and orange juice. Outside the window, hundreds of people prayed for her well-being and sang hymns of thanksgiving. She told police that she thought the reason for the kidnapping was that someone was trying to destroy her work at Angelus Temple, perhaps a jealous preacher of a different faith? Aimee claimed to have marched on through the desert until she saw a glow in the sky, which seemed like Heaven. It would be Agua Prieta and Schansel in his underwear.

She appeared distressed when reporters attempted to link her with Kenneth Ormiston, and they asked if she intended to marry again. She replied, "My life will always be for Jesus."

Cochise County sheriff J.F. McDonald was a typical western sheriff, accustomed to dealing with cattle rustling, bank holdups, bootleggers and the usual types of lawlessness on the U.S.-Mexico border, but the kidnapping of the world-famous female preacher was out of his line. When he received the news he drove from Tombstone to Douglas, where he found Aimee receiving a steady stream of visitors. After questioning her, he deposited her clothing in a bank vault and then headed for Mexico. In Agua Prieta, McDonald found Douglas chief of police Percy Bowden in conference with Agua Prieta's Chief of Police Sylvano Villa. They enlisted the help of C.E. Cross, a miner and cowboy, who was thoroughly familiar with the desert on both sides of the border.

Tracks matching Aimee's shoes, which were barely scuffed, were found about a mile and a half east of Agua Prieta, leading to Schansel's house. These tracks led from a shack used by the Mexican Federales near the border, but then the tracks stopped. The searchers returned to the hospital, where Aimee told them she had never crossed a road or a fence. This significantly limited the search area. She said the shack had wallpaper and a wooden floor. No one in the area knew of such an unusual shack. Nobody knew Rose or Steve either for that matter. They reported their lack of findings to Aimee, but her only response was, "Won't it be a glorious day when mother and the children arrive tomorrow?" She already had a $10,000 offer to appear in the Hollywood Bowl.

Minnie almost went into shock when she received the news that Aimee was alive, but she made immediate preparations to travel by train to Douglas with Aimee's children, Roberta and Rolf. As it turned out, the only people Aimee knew by the names of Steve and Rose were gypsies: Steve Uwanowich and his daughter, Rose Moreno. She had baptized them. The frightened Steve and Rose were immediately cleared of any association in the kidnapping. The second morning, Aimee was up at five o'clock talking to the *Bisbee Review*, saying that she simply must protest Sheriff McDonald's use of the word "mystery." She had told her story, and that was all there was to it. She gave a fervent "God bless you" before hanging up.

Along with her mother, Minnie, and children came Los Angeles chief of detectives Herbert Cline and his son-in-law, Los Angeles deputy district attorney Joseph W. Ryan. Cline hired a stenographer, and the ever-voluble Aimee gave thirty-five pages of testimony, which differed little from the story she had given reporters. She elaborated a bit under questioning on the details of the last shack where she was kept. It had no electricity but did have plumbing, even more unusual in the Mexican desert, where there were no plumbing pipes.

Ryan became more and more intrigued with the "Avengers" ransom note, almost two pages long. Kidnappers do not usually waste words in their messages. However, its statements confirmed Aimee's account about how she had been taken hostage. In fact, the note sounded an awful lot like Aimee.

Law enforcement had a hard time getting to talk to Aimee because she was always holding court with reporters. Finally, Minnie had the entire entourage moved to a suite at the Gadsden Hotel. On the third day, Aimee was well enough to accompany searchers on a junket into the desert. At Agua Prieta, she graciously thanked the Gonzalez family for their ministrations. Ramón told reporters, "I think the lady is a liar." The chief of the Mexican Border Patrol, Pedro Demandivo, said he did not expect to the find a shack because such a shack as the woman described simply did not exist. Three times, groups searched the desert, and three times, they found no shack. However, one party of searchers did find car tracks and a woman's shoe prints pointing toward town a couple of miles west of Agua Prieta. When reporters began to express doubts about her story, Aimee smiled and made thinly veiled threats of libel.

Aimee was well, and there was no longer any need for her to stay in Douglas. On the evening of June 25, Aimee, with a convoy of reporters, detectives and family, left Douglas on the Golden State Limited for Los Angeles. Two thousand people gathered at the station to bid her farewell.

Aimee thanked the people of Douglas profusely and promised she would one day build a church in their city. She closed with "Oh Douglas, God bless you!"

At Bisbee, a crowd formed, and Aimee gave them the benefit of her joyful presence. At about one o'clock in the morning, the train pulled into Tucson. Suddenly, Cline ordered Aimee to get up and get dressed. Expecting to see some of her followers, she put on her best dress and face. The only person she found waiting in a car was B.P. Greenwood, a Tucson building inspector. Cline asked Greenwood if he recognized the woman. He studied her and asked her to walk down the aisle. Then he said she looked like the woman he had given a ride to Tucson on the Douglas-Tucson road the previous Sunday and that she also looked like the woman he saw in Tucson about a month earlier. Aimee reminded Greenwood of the possibility of misidentification. Greenwood said what made him certain was her thick ankles. Aimee protested. Her ankles weren't so thick. (They were.) An hour later, she was still complaining about this allegation to tired reporters, who wished she would just shut up and let them get some sleep.

At Yuma the next morning, the train had to stop for eighteen minutes while Aimee received a loud ovation from a crowd who tried to touch her. "Praise the Lord. The hour of resurrection has come!" she responded. Near San Bernardino, five thousand followers listened as she spoke to them over a hastily constructed radio line connected to every station in Los Angeles and many along the coast. "This is Aimee Semple McPherson, of Angelus Temple, Los Angeles, California. God Bless you all! I am just bubbling for joy." Everyone recognized that throbbing, raspy Canadian accent.

When Aimee arrived in Los Angeles, sixty policemen, battalions of firemen and the temple's personal guard, escorted her to the temple, where thousands were waiting. Aimee preached and converted thousands in the next few weeks, but there were constant rumors that the kidnapping had been a hoax. During one meeting, thousands of her devotees raised their hands signifying that they believed her story. Why were the press and law enforcement so annoyingly dense? In a letter from McDonald to Ryan, the sheriff treated in a western gentlemanly manner the discrepancies in her account, and one can well imagine his reluctance to deal with women's undergarments. It read in part:

> *The day on which her hike was made was hot and she should have perspired freely. She wore corsets which should have shown signs of perspiration, yet I found no indications of excessive perspiration on her clothing. Furthermore*

I cannot understand why she did not discard the corsets. The heat would have made their presence known to her and however excited she may have been it would seem she would have thought of taking them off and throwing them away.

McDonald had helped revive people who had been exhausted on the desert and knew that one symptom was always present—an insane craving for water. In no part of Aimee's story did water play an important part. In McDonald's opinion her first request from Schansel at the slaughterhouse would have been for water. Finally, the shack in which she said she was held captive was never found. The sheriff indicated that he had no desire to cast any reflections on anyone, especially a famous female preacher, but he concluded that Aimee's story was not borne out by the facts.

When this became known, Aimee and her mother traveled back to Douglas. Fewer than a hundred gawkers greeted the train this time. One of the men who met the car was Reverend J.E. Howard of the Douglas Baptist Church. He had hoped that she would help with the building of a new church. Aimee was unkind to the few reporters, announcing that she did not wish to be bothered. Once again, she accompanied law officers and tried without luck to find the shack. She offered to walk twenty miles in the desert with no water, but reporters noted she drank water every few minutes after walking only a few feet.

On the way back to Los Angeles, reporters piled on the train at Yuma and tried to talk to Aimee. They had gotten a hold of a report by Boubion, who all but called Aimee a liar. Minnie peered out of their stateroom and motioned for them to leave. When asked about Boubion's report, Minnie rubbed her palm as if asking for money and said "That's Mexico!" Back in Los Angeles, Minnie announced that anyone who did not rejoice in Aimee's resurrection could withdraw their funds from the memorial fund; otherwise, it would go to the Bible school. By this time, the alleged kidnapping was an international incident, and an insulted Mexico was doing all it could to show that Aimee was a fraud.

In Tucson, a statement by car dealer C.A. Pape was released saying Aimee was the woman he had seen leave the International Club, a saloon in Agua Prieta, five days before her resurrection. What an ungallant thing to say about a female evangelist. Sheriff McDonald produced a signed statement that two men, by the names of Jones and Bermond, had seen Aimee with another woman and a man in a blue Hupmobile near Esqueda, Sonora. Reporters learned that this vehicle belonged to Harry D. Hallenbeck, who

lived on a ranch near Yuma. By then, there had to be a grand jury hearing. A diver had lost his life while searching for Aimee. If Minnie Kennedy had seen the ransom note before the memorial service for her daughter, then it was a felony to collect money for such a rite. It promised to be more fun than a barrel full of holy rollers, and Aimee never disappointed.

The grand jury hearing was supposed to be secret. However, Aimee refused to take the oath of secrecy on the basis that then she would not be able to discuss the case with her mother. Much to the embarrassment of the judge, she broadcasted everything that occurred in the grand jury room from her church radio on Sundays. She entered the courtroom dressed in her church regalia, consisting of a white dress and a gray-lined navy blue cape. Accompanying her was the vanguard of the temple, several ladies dressed just like their leader. They, in turn, were escorted by sheriff's deputies.

Law enforcement lost from the start. Aimee parried every feint with one of her own. District Attorney Asa Keyes tried to focus on monetary difficulties in the church. According to Aimee, there were none. He asked if relations between Aimee and her mother were strained. They were but she said the two women could not have been more loving. Could the kidnapping have been a publicity stunt? She sniffed that a woman of her character had no need for such things. Was she involved with Ormiston? Any man she chose would have to be a better preacher than herself and must know how to play the trombone. Every night, Aimee's followers listened eagerly for the day's events and there was nothing Judge Keetch could do about it. From his pulpit, Reverend Shuler denounced the District Attorney's Office for not competently prosecuting a woman, whose only strength was her control of mob psychology. Fights broke out on the streets between Aimee adherents and detractors. Aimee said she was being persecuted like Daniel in the Lion's den and Jesus on the cross.

Pape made a trip from Tucson and identified Aimee as the woman he saw at the International Club in Agua Prieta, Mexico. Aimee smiled enigmatically at him. That night, she stood in the church tank and baptized 134 new converts. Hallenbeck gave a full account of his activities on the day he was supposed to have been seen with her. It turned out that he was indeed one of her followers and knew Ormiston, who, he claimed, was in Los Angeles. A black man barged into the District Attorney's Office and announced that he had captured Aimee's abductors. In the fray that followed, the man was removed to the psychopathic unit of Los Angeles General Hospital after biting an investigator on the ear. Douglas, Arizona, underwent a tourist boom. Signs went up: "Aimee slept here"; other markers stated, "Aimee slipped here."

The jury was close to an indictment, but the district attorney decided to drop the case unless more information came forward. Then there was the little affair in Carmel, where Kenneth Ormiston, under the name George McIntyre, stayed with a woman at a cottage. Everyone knew it was Aimee, but when the grand jury reopened the case, no one from Carmel could positively identify her.

A letter arrived from Ormiston stating that he was at Carmel, but with a "Miss X," not Aimee. Grocery slips from the cottage at Carmel were recovered, and authorities intended to make a handwriting analysis. Then Mrs. A.E. Holmes, a member of the grand jury but not a member of the temple, for some reason known only to herself, excused herself from the courtroom and flushed the papers down the toilet. She was removed from the jury, but the District Attorney's Office took a lot of heat for letting this happen.

Aimee concluded that the whole affair was designed to break up her church. She lashed out at Reverend Shuler in a sermon: "The Devil's Convention is at its height." Shuler took exception to being likened to the devil. No matter, Aimee took on the District Attorney's Office. She said Ryan and Kline were Catholic men trying to persecute a protestant lady preacher. From the pulpit, Shuler shouted that Judge Keetch had discharged the jury to protect Aimee because they were both born under the British flag. McKinley, the blind lawyer who had initial contact with Wilson and Miller, was killed in a car accident before he could testify. Miss X might or might not have been the twin sister of a certified psychopathic liar, Lorraine Wiseman, who had been committed to an asylum in Utah by her husband. Wiseman testified that Ormiston was with her sister at Carmel.

On September 17, the Los Angeles District Attorney's Office filed complaints against Aimee Semple McPherson, Minnie Kennedy, Lorraine Wiseman and Kenneth Ormiston, charging corruption of public morals, obstruction of justice and conspiracy to manufacture evidence. Asa Keyes set himself up for the enormous task of proving a crime had been committed. The public became even more sympathetic to Aimee and many grumbled that Keyes should leave her alone. A big fight broke out between Aimee and her attorneys over Lorraine Wiseman, whom the evangelist chose to believe and befriend. Wiseman began hitting Aimee up for money to cover the bad checks she was writing. Minnie supported Aimee until she found out her daughter was slipping Wiseman money to the tune of one hundred dollars a shot. Aimee, usually glad to talk to reporters, became desperately ill. Doctors issued bulletins that she had an abscess dangerously close to the brain.

Day by day, she recovered. On a Sunday she put on a spectacular performance in the temple. She traced the events of her church's plight and likened it to the struggle between good and evil. Hordes of evildoers were bent on destroying the work of the crusaders for Christ. She started a crusade to raise money for her defense, called the "Fight the Devil Fund." First, she called for a $1,000 pledge, but that met with cool silence. She finally asked for anything the worshippers could spare, and then they dug deep into their pockets. Like Shuler, the police and the district attorney took exception to being referred to as Satan's workers, so Aimee was urged to change the fund title to the "Aimee Semple McPherson Defense Fund."

On September 27, the preliminary hearings opened with the arraignment of Minnie Kennedy and Aimee. It was a rehash of the grand jury hearing, with no significant new information. The elusive Miss X and Ormiston could not be found. Douglas policeman Alonzo Murchison testified that his conclusion was that Aimee had walked only a little way around the port of entry and the Agua Prieta slaughterhouse. He also pointed out the lack of perspiration on the dress and scuff marks on the shoes. Her shoes, in fact, were grass stained, and what is rarer than grass in the Mexican desert? One by one the prosecution's witnesses fell. Was this the woman they had seen during the time of Aimee's disappearance? "Nope." Even C.E. Cross, the veteran desert tracker, said she could have traveled fourteen hours without water and not necessarily have scuffed her shoes. Later, he got cake and ice cream at Aimee's house. For the most part, the Arizona contingent, including the truant officer who took her to the hospital, supported Aimee.

Aimee stood up in court and, in her best pulpit voice, announced, "As God is my judge I am innocent of these charges." Three days later, she preached one of her most popular sermons, "The Greatest Liar in Los Angeles." The liar, of course, referred to Keyes. On January 10, District Attorney Keyes asked the court to dismiss charges against everybody on the grounds that it would be impossible to get a conviction. The court agreed, and Aimee was free.

Aimee continued to build her congregation with her fervent preaching. However, she was continually in and out of court. There were lawsuits against her mother; her daughter, Roberta; and various members of Angelus Temple who Aimee thought were getting too powerful. Her brief marriage to David Hutton in Yuma, Arizona, ended in divorce.

On September 27, 1944, during World War II, Aimee again made international headlines. That morning, her son, Rolf, found her unconscious and breathing heavily. The doctors came, but it was too late. Aimee Semple

McPherson was dead. The first announcement was that she had a heart attack, but then it was revealed that she had taken an overdose of barbiturates. Whether this was by design or accident is another mystery. Questions were raised about why the pills were in a plain bottle with no indication of a prescription. For three days, Aimee lay in state in Temple Angelus while more than ten thousand people marched past her coffin. Her final service was a grand display of shouting, swooning and speaking in tongues. She took to her magnificent grave the mystery of where she really was those five weeks before turning up in Douglas, Arizona.

NINETEEN DAYS UNDERGROUND

The year was 1934, and Tucson, like the rest of the nation, was struggling to survive the Great Depression. In January, the town had done itself proud when its law enforcement personnel captured gangster John Dillinger and several of his henchmen. Two years earlier, kidnappers had taken Gordon Sawyer, vice-president of Southern Arizona Bank. A ransom note demanding $60,000 was delivered to Fred J. Steward, president of the bank, on January 5, 1932. With the help of pioneer aviator Charley Mayse, the kidnappers were spotted the next day on west Grant Road. Sawyer was freed, and one of his abductors, Clifford Adkins, was captured and brought to trial. Tucson had utmost confidence that law enforcement would be able to find one little girl who disappeared on April 25, 1934.

On that day, six-year-old June Robles left Roskruge School for her cousin's home, where she normally waited until her mother and father got off from work at their electric shop. She never arrived. Nineteen days later, she was found, safe and sound, buried underground in the desert area east of Wilmot Road. There were no shortage of suspects, but no one was ever convicted. June Robles was the daughter of Fernando and Helen Robles; the granddaughter of Bernabe Robles, a wealthy rancher and real estate developer; and the niece of county deputy attorney Carlos Robles. The kidnappers might have been trying to get revenge on Bernabe Robles, who was born in Babiacara, Mexico, on August 24, 1857. Six years later, traveling by burro, he and his mother arrived in Tucson. He started a business in Tucson selling bread. Later, he operated a stage line, a saloon and a general mercantile and sold

Above: June Robles's underground cage contained a large amount of garbage. *Courtesy Arizona Historical Society.*

Left: June Robles posed with her mother, Helen Robles. *Courtesy Arizona Historical Society.*

real estate. Robles opened the old Robles Road, now known as Ajo Way, when he ran the stage line from Tucson to Quijotoa, a mining camp. He bought up land along the route for the purpose of supplying water to his horses, and before long, he had one of the largest ranches in southern Arizona. In 1917, Robles retired from ranching and moved his family to Tucson, where he sold and bought real estate.

About 5:00 p.m. on the day of the kidnapping, a stranger paid a newspaper boy, Rosalio Estrada, a quarter to take a note to Fernando Robles. Estrada entered the Robles Electric Company shop with the note, which he handed to June's father. It was a ransom demand for $15,000, with complicated instructions about how and where the money was to be paid. The note, signed "XYZ Obey," contained a grim warning as to what would happen to June if the contents were revealed. Upon receiving the money, the child would be delivered to the family. When Fernando dashed outside, the stranger was gone. The family had no intention of showing the note to the police, and it is not certain how the note came to the attention of law enforcement personnel.

June's cousin Barney Kengla had run on ahead of her after school. He turned to see June talking to a man and getting in a black car near Fifth Street and Second Avenue. This was all the child could tell the police. The sheriff's office immediately threw up a watch at all the principal exits of the city. Those who thought they saw the kidnapping described the car as a Model T Ford with its license plates bent up so the numbers could not be read. One woman described the man as dressed shabbily in a loose-fitting dark suit with a hat pulled low over his face and wearing sunglasses.

On the second day, more than three hundred armed American Legionnaires joined scores of federal, state and local police to search for the missing child. Pima County sheriff John Belton and Tucson chief of police Gus Wollard worked their staffs around the clock on the case. Governor Benjamin Moeur announced that the entire highway patrol would be sent to Tucson to investigate the case.

Fernando, haggard with worry, told reporters, "I don't have $15,000 and I never did, and right now there doesn't seem to be any hope of getting the money." Law enforcement officers protested that the inability to get the $15,000 from the grandfather hampered early efforts at clearing up the case. In a bold move, a second note addressed to the grandfather was shoved under the door of Carlos Robles's office on the second day. The kidnappers offered to reduce the ransom from $15,000 to $10,000, provided that Robles acted quickly. Speculation ran high that revenge for

some wrong by the grandfather in his business dealings was the motive for the crime.

On the third day, Bernabe Robles offered to pay the $10,000, provided June was returned alive. The father made an appeal through the newspapers, saying the $10,000 would be paid and that he had been unable to raise more but that the abductors had to show proof that June was alive. This was to be accomplished by publishing in the newspaper a series of questions, the answers to which only June would know. A Tucson city police detective, who wished to remain anonymous, announced that the Robles family had negotiated with the kidnappers.

Meanwhile, three University of Arizona boys got in big trouble when they decided to play a practical joke and offered a newspaper boy ten dollars to take a note to the Robles family. The boy took the note straight to the police, and the pranksters spent a few days in jail. Mob violence threatened as angry citizens milled around the sheriff's office talking about a lynching. Just whom they were going to lynch is not known. One man was heard to say, "Well, I hope they [the kidnappers] get the money!" He was arrested but later released. The abductors might have become frightened by the mood of the town and made no further attempt to contact the family. Seers, crackpots and well-meaning citizens deluged the police and sheriff's offices with a flood of clues. The hottest tip was given by a woman who lived at Country Club and Fort Lowell, who said she heard a child's screams about a quarter of a mile from the house.

It did not help matters any when the Arizona Highway Patrol and the Tucson police became embroiled in a fight, charging each other with failure to cooperate. In a startling move, county deputy attorney Carlos Robles issued a statement in the local newspapers calling off all volunteer searches for his niece. Law enforcement officers still had a responsibility for the case but indicated that they were not getting cooperation from the family. The desert, particularly on the international border, was scoured, and a Tucson house-to-house search was made, which turned up nothing. Then Carlos Robles requested that all law enforcement personnel withdraw from the case so that the family could make contact with the abductors. Bernabe's intentions were to deliver the ransom money himself. He had no luck, even though he followed the kidnappers' instructions and made long midnight rides into the desert. At a certain signal, he was supposed to throw the money out of the window, but night after night, the signal never came. By this time, it was believed that one woman and two men were involved.

The grandfather made a quick trip into Mexico, and there were conjectures that he was about to take action on the kidnapping himself. On April 30, the Robles family issued a plea via the newspapers, begging the abductors to let them enter into arrangements that would provide for June's safe return. Services of an intermediary were not approved of by the grandfather, in spite of recommendations by family members, who believed this was the most effective means of contacting the kidnappers. Bernabe appeared determined to go at it alone in an effort to effect the return of his granddaughter. There was growing apprehension for the child's safety.

José Figueroa from Santa Ana, Mexico, told reporters that Bernabe had sought help from Manuel Gamboa, who had a reputation as a seer among the residents of Sonora. The seeking of supernatural aid fueled the rumor fires in Tucson. On May 2, the grandfather, along with friends Henry Dalton and Al Aguirre, made another journey to Mexico. Upon his return, the grandfather refused to comment on the case, but Dalton told reporters that the trip was "a wild goose chase." Aguirre would say only, "The child is safe." The area around the Robles home on Franklin Street went into an uproar one evening when a truck backfired and everyone thought the kidnappers and officers were exchanging gunshots.

The day after June's kidnapping, the Federal Bureau of Investigation (FBI) became involved and set up an office in the Pioneer Hotel, but Special Investigator Joseph E.P. Dunn was reluctant to move after the family requested the hands-off policy. By May 9, June Robles had been missing for two weeks. Again the abductors made contact with the family with a third note, and there were assurances that the child would be returned if the ransom payment was met. By this time, law enforcement officials believed the kidnappers were operating outside Tucson. Again the family was unable to make contact, and FBI agent Dunn admitted the Justice Department was "licked."

This was the period of the Lindbergh kidnapping, and the Robles kidnapping had made national news. Dead-end tips came in from all over the country; she was reportedly seen from as far away as Gulfport, Mississippi. Cananea, Mexico, was searched house to house. A posse of bandoleered Mexican Federales cordoned off a shack near Naco, where someone had seen a couple of men with a little girl. All of these efforts were futile.

On May 14, nineteen days after she was kidnapped, a dazed June Robles was found in an underground cage. She was dirty, covered with vermin and had scars on her ankles where the chain had been too tight, but other than that, she was in good health. Food to the extent of a container of tepid water, wilted vegetables and bread were found in

her cage. A communication had been sent from Chicago to Governor Benjamin Moeur in Phoenix, who was out of town. The governor's secretary, Herbert M. Hotchkiss, spotted the anonymous dispatch and sent a state highway patrolman to deliver the note with its instructions by car to the county attorney in Tucson. The note read: "Her body will be found in a buried box. Go out Broadway to Wilmot road. Turn south to Rincon Way. Go one mile, then walk 150 steps into the desert."

County attorney Clarence Houston called Carlos Robles into his office and said, "Carlos, I have some bad news for you," as he handed him the Chicago letter. Houston and Carlos drove to the site and searched for several hours, fully expecting to find a dead body because of the nature of the note. Their fears were reinforced as they watched buzzards hover over the site. Just as they were about to give up, Houston stumbled across the top of a crude cage buried in the ground and covered with cactus plants.

Houston opened the lid and found June alive, shackled to the corrugated iron cage by a tire chain manacled to her ankle and welded to a steel rod driven in the ground. A key was on top of the cage. Houston said, "Hello, June. Do you know me? Are you afraid of me?" She replied, "Hi! No, I am not afraid of you." Then Houston threw her the key and she opened the lock by herself. The cage eventually went to the FBI office in Washington, D.C. Other clues at the site included a napkin from the French Café, a business card from a Nogales bartender, two beer bottles, a package of cigarettes and several sets of fingerprints. The Department of Justice had reason to believe June's kidnapper was in the Chicago area, and a search was launched. Police in suburban Oak Park received a telephone call from a man who told them that if they were interested in the Robles case to go to a certain Loop hotel with $25,000 to give to Bernard Franklin. A Bernard Franklin was found in the hotel, but he satisfied authorities that he had no connection to the Robles case. After resting for a few days, June described to reporters how the man lured her into the car by saying he was taking her over to her father's electric shop. She gave her abductors' names as Will and Bill and said they threatened to whip her if she cried. She said one day, three men came and brought her sandwiches. Several times she stated that she was not frightened, leading some to wonder whether she might have known her abductors.

With June safe, law enforcement personnel from several agencies made an all out search to find the kidnappers. On November 14, Oscar H. Robson, who ran a Tucson dance hall, was accused of the Robles kidnapping. He was arrested and held incommunicado in a Phoenix jail, where he spent almost three months. Bond was set at $100,000. The lineup of circumstantial

evidence included Robson's purchase of a large quantity of the foods similar to those found at the kidnapping site from a local market, the analysis of the printed writing on the extortion notes and of Robson's handwriting and printing obtained from the Southern Pacific Railroad, where he had been previously employed. All of the routes driven by the Robles during the time of the kidnapping were in the vicinity of Robson's family connections on Swan Road. Law enforcement officials noted that automobiles driven by the Robson family group made several forays into Mexico.

However, June failed to identify him as her abductor. Robson's alibi was that he had been in Phoenix at the time of the abduction. On December 9, Francis Del Crosby, a nightclub impresario and former business associate of Oscar Robson, was extradited from California and held in custody in the Pima County jail for writing a bad check six months earlier. Sheriff Belton claimed he had knowledge that prompted him to want to know more of Crosby's movements during the time of the kidnapping. At the time of June's abduction, Crosby was supposed to have been negotiating for the purchase of the Tucson Country Club and might have needed the money. However, he denied any knowledge of the kidnapping of June and, after questioning, was set free. The first grand jury failed to indict or exonerate Robson. In December, he was smuggled into Tucson and lodged in the Pima County jail. His bail was lowered to $50,000 and ultimately to $5,000, which was posted by his mother, his estranged wife and a prominent southern Arizona rancher, Paul B. Watkins. The second grand jury in Tucson probed deeper into Robson's activities.

An ex-con, William Lindstrom, was alleged to have a connection with the Robles kidnapping. Lindstrom had been sought by authorities as a fugitive from justice since April 23, when he failed to report to U.S. District Court on a charge of importing narcotics. He appeared in Phoenix and told officers of having been kidnapped in Tucson on April 10 and held prisoner in Coolidge. Officers reported that while they were returning him to Coolidge, Lindstrom suddenly died.

J. Edgar Hoover, head of the FBI, announced in Washington, D.C., that federal handwriting experts were in Tucson and would name Robson as the writer of the ransom notes. He also pointed out that they could not say that Robson actually did the kidnapping. On May 4, a federal grand jury indicted Oscar H. Robson on a charge of mailing threatening communications with intent to extort in connection with the kidnapping of June Robles. At the request of government attorneys, federal judge Albert M. Sames authorized the grand jury to continue its investigation. Robson's counsel, Fred W.

Fickett, suggested that Hoover be subpoenaed to testify if he knew so much. More than seventy witnesses, including June, were called and the presence of a mystery witness in overalls and a slouch hat known only as a rancher set the rumor mill buzzing. After eighteen months, charges against Robson were dismissed. The jury's findings read in part: "We feel that the federal authorities have done everything possible to solve this case, but we do not feel that the facts disclosed by the evidence are sufficient to warrant the indictment of any person, or persons."

The jurors referred to the case as an *alleged* kidnapping, leading many to question whether June Robles had spent the entire nineteen days underground. Others whispered that the kidnapping was a fake because efforts of investigating agents always led to blind alleys. For a while, it appeared that June Robles would enter the movies or go into vaudeville. Several filmmakers were interested in her story, but the family declined to make any money out of the ordeal.

On August 16, 1937, a woman from Phoenix testified that she had intimate knowledge of the kidnapping. She said the kidnap plot was devised by a Nogales man and two Phoenix friends during a drinking spree in the border town. Terrified at the reaction to the kidnapping, the Nogales man gave up trying to get the ransom, hid June in the underground cage and had the letter describing her whereabouts mailed by a friend in Chicago to Governor Moeur. Acting on the advice of his attorney, this man wrote a bad check for a small amount, got himself arrested and placed safely in jail in another Arizona town. The next year, he committed suicide by swallowing poisoned tablets used in coyote bait. In response to this allegation, the FBI said, "We believe the kidnapper of June Robles died in 1935." The transcript was deposited and sent to the National Archives in Laguna Niguel, California. Sometime in the 1940s, the transcript of the grand jury hearing was supposed to have been returned to the Arizona Superior Court, but it seems to have disappeared. The kidnapper of June Robles evidently committed the perfect crime. June died recently, taking her secret to her grave.

8
JAMES KIDD'S SEARCH FOR THE SOUL

All anyone remembered was hearing a car screech to a stop and a door slam shut on that crisp November 10, 1949 morning. James Kidd, a prospector in his seventies, left and never returned to his four-dollar-a-week room in Phoenix, Arizona. Very little is known of James Kidd. He did have heart trouble because in September 1942, he was hospitalized at the Miami-Inspiration Hospital for about a month after he collapsed at a Miami Copper Company pumping station during a pump accident. Kidd filed a claim with the Industrial Commission, asserting his chest pains were caused by the accident when he was hit in the chest by the stem of an eight-inch pipe. The accident did occur, and Kidd was injured; however, his claim for workmen's compensation was disallowed on the basis that it was his heart problem, not the accident, that incapacitated him. He was offered a position as watchman at the mines, but he refused this job and moved to Phoenix.

Kidd first arrived in Arizona around 1920 after tramping around Montana, Nevada and California, some said as a hobo on the railroads. At the Miami Copper Company, he told employers that he had been born in Ogdensburg, New York, on July 18, 1879. Although there is no such birth record, this information was also given on his voting registration. He was remembered as a quiet, pale man with an "eastern accent," about five foot ten, who read a lot and quoted Omar Khayyam. While other miners searched for bootleg whiskey and a card game, Kidd did not drink and rarely gambled, except in Las Vegas and then only on a fixed amount. He wasn't married but had an eye for pretty women. He always wore an uncreased fedora, even while a patient in the hospital. Those

This is the only known photograph of James Kidd.
Courtesy Phoenix Gazette.

who knew him said he was bald. Kidd could be sociable or a loner. He frequently went on prospecting trips into the nearby mountains.

In 1933, he registered two mining claims, which are listed as Scorpion 1 and Scorpion 2, at the Gila County Recorder's Office. Kidd kept up the affidavits of labor and made his yearly payments on these properties at the Gila County Recorder's Office until 1948. Many have tried to find the Kidd claims. They are listed in the Pinal County Recorder's Office as Scorpion 1, filed on September 23, 1933, and Scorpion 2, filed on October 26, 1933.

Both Scorpion 1 and 2 have identical listings. Kidd's partner, Beach, died two years before Kidd disappeared, and nothing much is known about him. Some think the claims are in the Pinto Creek area; others believe they might be in the Superstition Mountains. Although the claims were filed, Kidd never completed the location notices with a full description. While working for the Miami Copper Company, Kidd frequently visited a Globe stockbroker, Fred A. Nathan. When Nathan moved to Phoenix to work for E.F. Hutton, Kidd visited him there, making the trip by bus. Kidd never owned a car or had a driver's license. He would hitchhike or take the bus to wherever he was going. When he ate in a restaurant he always ordered the cheapest thing on the menu while keeping an eye open for a discarded newspaper. He treated himself to a nickel cigar and made it last all day.

By 1949, Kidd was living in Phoenix at 335 North Ninth Avenue in a one-room hovel for which he paid four dollars a week. On November 9, he told

a neighbor, Dave Crumrine, that he was going to the Globe-Miami area to work on his claims. He borrowed a pick from Crumrine. Kidd told another acquaintance, Pete Eastman, that he was leaving early the next morning with a friend, who had a car. It was not at all unusual for Kidd to be gone for several days at a time, but when he had not returned by December 29, his landlord, F.J. Pentowski, reported Kidd as missing to the Phoenix Police Department. Immediately, something unusual about this case came to attention of the police. Officer William Gragg, in Crumrine's presence, inspected Kidd's room and found that he had $3,800 in a Valley National Bank checking account. Another note indicated that he had recently received a large dividend from the Hudson Bay Mines and Smelting Company—rather unusual for a man who lived on the edge of poverty.

Because he apparently had no heirs, there was never any great effort to find him. Kidd might have been entirely forgotten, except for the fact that in 1956, the Arizona legislature passed the Uniform Disposition of Unclaimed Property Act, which stipulated that property unclaimed after seven years should, after due process, revert to the State of Arizona. Geraldine Swift, estate tax commissioner, became the receiving agent for hundreds of inactive accounts, including that of James Kidd. E.F. Hutton sent in its report on the Kidd account, along with a check for $18,000 for liquidated securities.

Records indicated that Kidd had acquired thousands of shares of stock during the 1920s and 1930s. Unusual stock, such as the White Caps Gold Mining Company and Cow Gulch Oil Company, was interspersed with railroad stocks, Hudson Bay Mining Company and other solid securities. Then a safety deposit box in Kidd's name turned up in a Douglas bank. After drilling it open, auditors discovered it contained additional stock and pictures of Kidd. By now his portfolio was valued at around $200,000, and Swift did everything she could to locate any heirs.

Periodically, Swift inventoried the Kidd estate in the dusty basement of the Valley National Bank. On January 11, 1964, she once again audited the Kidd material. When she flipped through a sheath of stock purchase receipts, which had been ignored because they were of minor importance in the estate, a note handwritten on old ledger paper fell out. She was stunned to discover James Kidd's will. It was unwitnessed but definitely in Kidd's handwriting, and such a will must be probated in Arizona courts. It read:

Phoenix Arizona Jan. 2nd 1946. this is my first and only will and is dated the second day in January 1946. I have no heirs, have not been married in my life, after all my funeral expenses have been paid and about #100, one

hundred dollars to some preacher of the gospital [sic] to say fare well at my grave sell all my property which is all in cash and stocks with E.F. Hutton Co in Phoenix some in safety box, and have this balance money to go in a reserach [sic] or some scientific proof of a soul of the human body which leaves at death. I think in time their [sic] can be a photograph of the soul leaving the human at death, James Kidd

Geraldine Swift was empowered to take possession of Kidd's estate for the State of Arizona, but she was determined to make the courts decide whether or not the will should be probated. Assistant Attorney General Robert Murlless was convinced that the will was the product of an unsound mind and should be thrown out and that the money should go to the State of Arizona. The decision would be made by Judge Robert L. Myers, judge of the Superior Court of Maricopa County, who threw out the state's claim early in the proceedings. The immediate question was if the will were probated, how could it be determined who should receive the money?

Before the judge could decide if the will was valid, there were difficulties. Evidently, someone in the Superior Court was a member of the University of Life Church, and this person leaked the contents of the will to the congregation. On March 5, 1964, this organization filed a motion to dismiss Arizona's claim to the money. It also asked the court to probate Kidd's will as a charitable trust for which the church could qualify.

The church's minister, Reverend Richard T. Ireland, combined spiritualism, ESP and religion for entertaining performances before his congregation. The church held classes to teach the return of the spirit and conducted séances purported to demonstrate continuity beyond the grave. Its petition promised that "these spirit communion séances shall include trumpet, or direct voice rapport and materialization, and all phases of physical mediumship." It was a portent of the onslaught that Judge Myers would face, and it is to his credit that he kept the process from becoming a circus. He would need the wisdom of Solomon, all his legal training and a healthy sense of humor to sustain him through the upcoming ordeal.

James Kidd, an indigent miner about whom no one cared enough to even look for, suddenly had a host of relatives, including brothers, wives and children. Two men in their eighties, John Herbert Kidd and Herman Silas Kidd, from Ontario, Canada, asserted that they were blood brothers of James Kidd, whose full name was Enos James Kidd. Maxine Tustian of Toronto claimed to be Kidd's niece. They filed a motion that Kidd was not mentally capable of drawing up a proper will and that the money should go to the heirs

apparent. The brothers would both die before the proceedings were over. The University of Life Church filed a motion that all Kidd aspirants admit that the will was written by James Kidd and that all Kidd heirs file a genealogical chart with pertinent data on each family member.

On April 16, 1950, six months after James Kidd disappeared, someone (possibly Kidd himself) made an entry into his safe deposit box in Douglas. The signed entry slip was in Kidd's handwriting. Did he remove some securities or add some more stocks, or was it an excellent case of forgery? If the latter, how did this person have the requisite key to the safety deposit box?

Then a couple of wives turned up. Elyse Demontmollin Kidd of New York City said she was married to Kidd in Mexico and had documents, certified by American consular officials in Mexico, to prove it. She asserted that they had lived together in Los Angeles before Kidd deserted her in 1939 to return to Arizona, and she wanted half of the estate as community property. Handwriting expert Morris W. Duncan pronounced Kidd's signature on her document a forgery. A seventy-year-old Wisconsin woman said she was married to Kidd in 1913. She laid no claim to the estate, but her children indicated they might try for the money. They didn't file for the money probably because they weren't his children.

When the public announcement broke, there was a deluge of applicants for the money. Some were legitimate soul searchers, but many were out-and-out crackpots. One man said he could prove the existence of the soul and that James Kidd had been inspired by the Holy Spirit to write the will. Others wrote asking how they could enter the Kidd mystery contest. One down-to-earth inquirer wrote that the only way to prove the existence of the soul was to die. A man from Brazil said a human has two souls, one black and one white. "Which one do you want me to prove the existence of?" A woman said she would be less than honest if she did not admit she wanted some of the loot to buy a new pair of false teeth.

Before Judge Myers heard the case, 133 claimants had paid the fifteen-dollar fee and filed a claim on the eccentric's money. The international list, including the needy and greedy from all over the United States and several foreign countries, consisted of eccentrics, supposed heirs, various parapsychology organizations, swamis, yogis and institutions of higher learning, such as the Arizona Board of Regents making application for the proposed new College of Medicine of the University of Arizona. Later, the board of regents' claim was transferred to Northern Arizona University, but the University of Arizona got there first. The Barrow Neurological Institute had an opinion on the location of the human soul during life, based on its

work on cats. The combatants in this metaphysical war had two things in common; they all wanted the money, and except for heir aspirants, they were all perfectly willing to affirm that they were the best suited to prove the existence of the soul. To add to the confusion, the judge received a letter just before the trial from someone who signed himself as James Kidd. The envelope was postmarked Phoenix, with no return address:

> *If you are wondering why this letter is typed, 8 years ago I was hurt in a fall and my hand partially paralyzed. My handwriting is now illegible. I have a false name and I am watching the whole thing about the distribution of my money. I have always wanted to see what a person would do if given the chance to a large amount of money. Please go on and find a worthy person for my money. Thank you for your concern. Quite alive, James Kidd*

Because Probate Case Number 58416 in the matter of James Kidd, Deceased, was not a trial but a hearing, claimants were allowed to cross-examine one another, which made for interesting moments in the packed courtroom. Most of the testimony centered on esoteric philosophical discussions of the soul, but there were plenty of interesting applicants. Dr. Joseph W. Still, a California physician who had written a book, *Cybernetic Theory of Aging*, was represented by none other than Melvin Belli. Attorney Paul Sloane said the money should be distributed to various universities, with himself as co-trustee. A prospector from Apache Junction, Ludwig G. Rosecrans, based his qualifications on having written a manuscript concerning the human soul that he called the "The Kingdom of Reality," which was so terrifying it "can never be published by any commercial publishers." He asserted, "Something cataclysmic happened to humankind in 1950 which upset the balance of man's mind." Lieutenant Colonel Virat Ambudha, on leave from the Thai army and in civilian clothes, pressed his claim.

One of the most legitimate claimants was Dr. Gardner Murphy for the American Society of Psychical Research. Murphy, the first to present a case, had served as director of research for the prestigious Menninger Foundation. He dwelt on the need to physically prove the soul leaving the body at the moment of death, which was the crux of Kidd's will. However, he declined to say that the existence of the soul could be proved. In an understatement, he reflected, "If we could contact a spirit after death, it would solve a lot of problems."

The University of Arizona Board of Regents was represented by attorney Gary Nelson. The regents changed their claim from the original one made by the medical school to a petition from five faculty members of the Philosophy

Department of Northern Arizona State University, proposing to set up a James Kidd Chair of Philosophy. This change was based on the controversy of the definition of the soul. People who had never thought much about the soul before now hotly debated the subject. The problem with the Barrow Neurological Institute was that it was part of St. Joseph's Hospital. Claims were made that because a Catholic institution already believed in the soul, Barrow could not be trusted to carry out impartial research in a purely scientific fashion.

Nora Higgins, a California medium, told the court that Kidd had appeared in her bedroom just after she finished her housework. She said, "Good morning." Kidd just smiled before disappearing into a fluorescent light and up through the ceiling. When showed a picture of Kidd, she readily admitted that he was the one. Higgins, confident of her own psychic powers, told the judge that Kidd was pacing up and down the courtroom with his hands behind his back, shaking his head. She told reporters that Kidd had whispered to her that "things were not working out." Jean Bright, also from California, claimed she had been in constant communication with her dentist who had died. She said when she asked a question of the soul of her dentist, he would either nod or shake his head. The dentist was anxious to appear in court to prove his existence so his family would know he had survived. He never showed up. Earl W. Johnson, who had spent time in a Missouri insane asylum, said he was the only sane person to seek Kidd's fortune. He had a certificate from the institution, proving he was sane. The fifty-six-year-old white-bearded transient claimed he was born dead and brought to life later. "I'm just going to tell the judge my story. If he doesn't believe it, that's his problem."

During the hearings, Judge Myers received many instructions and admonitions as to how the proceedings should be conducted. One man wrote to say proof of the soul was simple and all Myers needed was John 14 from the scriptures and twenty-twenty vision. After Myers disqualified the claim of Reverend Robert Raleigh, prelate of the Church of Antioch—supposed to have been founded by the Apostle Peter in AD 38—the minister told Myers he should disqualify himself for "usurping the power of God."

On September 1, 1967, the hearings came to a conclusion after about 800,000 words of testimony. On the final day of the hearing, Judge Myers remarked that he would seek divine guidance before coming to a decision. All heir aspirant claims were thrown out for lack of substantiation. He arrived at his decision on October 20, 1967. The money was awarded to the Barrow Neurological Institute in Phoenix, Arizona.

If the two Canadian men's claim that they were Kidd's blood brothers were true, it would explain Kidd's accent, which so many people described as

"back East." It could also be that Kidd came into the United States illegally from Canada, never becoming a citizen, and gave the New York birthplace to avoid a hassle. Because Ogdensburg did not keep birth records at the time, no one could deny or verify his claim. The Kidd rumor mill was always busy, especially in the Globe-Miami district. Some alleged that Kidd trafficked gold bullion from the United States into Mexico, a common but very illegal and dangerous action. At that time, it was unlawful for a U.S. citizen to own gold, and Mexican con men bought gold off prospectors at very low prices. Frequently, these prospectors would be murdered, eliminating the necessity of any payment. If Kidd had been doing this, it would explain his safe deposit box in a Douglas bank near the border. Another story circulated that two other prospectors were trying to jump Kidd's claims. They may have shot Kidd and salted his body away in one of the thousands of open Arizona mine shafts. Supposedly, one of these claim jumpers died of insanity at an asylum.

The Kidd hearing did not end with Judge Myers's ruling. On January 19, 1971, the Arizona Supreme Court overthrew the ruling and sent the case back to Myers. The case was overturned on the basis that Barrow had never and did not intend to in the future do research on whether a soul exists in the human body. Myers was instructed to give the money to one of four claimants that had done work in soul research: the American Society for Psychical Research; Dr. Joseph Still of Los Angeles; or Reverend Russell Dilts of South Bend, Indiana. Ultimately, the money went to the American Society for Psychical Research, Inc., in New York City and the Psychical Research Foundation in Durham, North Carolina. Reports of how the money was spent are in various journals and in the book *At the Hour of Death* by Karlis Osis and Erlendur Haraldsson, published by Hastings House, New York. The experiments involved out-of-body experiences and a study of reports of visions of dying patients. From the terms of his will, the money was probably spent in a manner of which James Kidd would have approved.

Several questions remain. Did Kidd die a natural death from a heart attack somewhere on one of his mining claims? Was he murdered? Or did he take on a new name and identity to later enjoy the court fight in Phoenix over the quarter of a million dollars? How was he able to amass such a fortune on the salary of a pump man who made about six dollars a day in the 1930s and 1940s? Did Scorpion 1 and 2 provide him with all this money, and where are they located? Finally, can anyone prove the soul exists or photograph a soul leaving the body?

9
STONES FROM HEAVEN

You would think that chunks of iron weighing tons that blasted through the cosmos might have left an indelible etching on the memory of those living in southern Arizona at the time of their arrival or discovery. You would think that more than two pieces would have been found by now, given that records indicate that several masses of virgin iron lie scattered around the Santa Rita Mountains. But then Tucson meteorites might have arrived long before humans trod the solitary southern desert. There are only the most vague stories that recount how these chunks of iron were brought in from the Santa Rita Mountains when Arizona was part of New Spain and how pragmatic pioneers found them useful as anvils for military and civilian blacksmiths. Native peoples have always worshiped stones from heaven. It is curious that the stones from heaven did not find a place in the ancient Native American tribal legends.

The meteorite known as the Ring, or the Ainsa-Irwin, meteorite weighs around 1,400 pounds and served as a military anvil when Tucson was a presidio outpost of New Spain. When used as an anvil, it was turned upside down and partially buried in the ground to give it stability when worked by blacksmiths. A 30-pound fragment was broken off the Ring to provide samples for museums throughout the world. The Carleton, or whalebone, meteorite was named after the Civil War general James H. Carleton. It has a shape similar to a whalebone and shows no fit with the Ring, but it is similar in chemical composition and structure. The Carleton meteorite weighs about 633 pounds and was partially buried on one end to provide a surface for the

Left: The Irwin-Ainsa Meteorite, also known as the Ring Meteorite, may be seen in the Smithsonian. *Courtesy Smithsonian Institution.*

Below: California scientists studied the Carleton Meteorite, or Whalebone Meteorite, before it was shipped to the Smithsonian from California. *Courtesy Smithsonian Institution.*

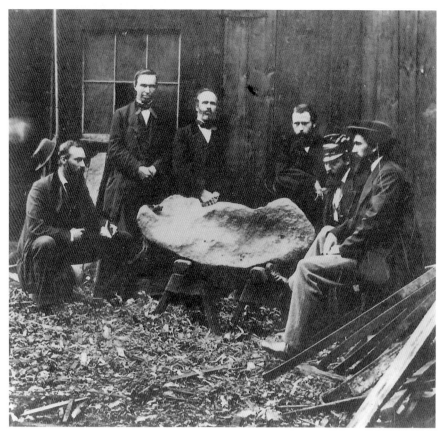

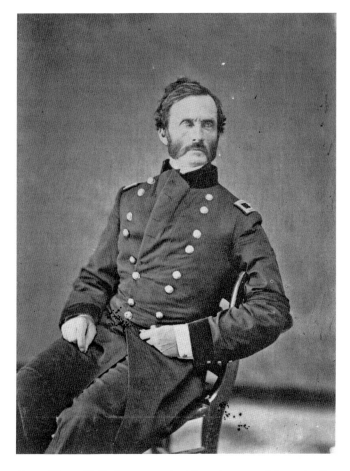

General James H. Carleton recognized the uniqueness of the meteorites when he passed through Tucson. *Courtesy Library of Congress.*

civilian blacksmith Ramón Pacheco. Both meteorites are uniquely different from any other known meteorites and appear to have come from the same parent mass.

Tucson offered few of the amenities of civilized life, and visitors often slept in the livery stables with their horses. This was not because they could not afford a hotel room but because there were none to be had. Many of those who visited it felt like J. Ross Browne, who wrote:

> *Tucson was a place of resort for traders, speculators, gamblers, horse thieves, murderers and vagrant politicians. Men who were no longer permitted to live in California found the climate of Tucson congenial to their health. If*

the world were searched over I suppose there could not be found so degraded a set of villains as then formed the principal society of Tucson. Every man went armed to the teeth, and street fights and bloody affrays were of daily occurrence. It was literally a paradise of devils.

Tucson was staffed mainly with soldiers, a few merchants and a chaplain who said Mass in a tiny chapel. With the discovery of gold in California in 1848, Tucson became a rest stop and commercial site for gold-seekers. Here they could obtain water and food, have their horses shod and the wheels of their wagons repaired. At first, only small houses rose up, and as one author wrote, it was in the middle of nowhere that became a somewhere. Repair wagons and shoeing horses required the services of a blacksmith, and a blacksmith needed an anvil. The meteorites served as perfect anvils. The first description of the meteorites occurred in 1845, when José Francisco Velasco wrote a description in his *Noticias Estadísticas de Estado de Sonora*. Tucson was in the Mexican state of Sonora at the time. Velasco had sound credentials, having served in Mexico's First General Congress and participated in the early Mexican state conventions. He was a fellow of the Mexican Society of Geography and Statistics and also enjoyed a good scientific reputation. He wrote:

Between the presidio of Tucson and Tubac, there is a sierra called de la Madera and Puerto de los Muchachos (mountain pass of the children). In it are seen enormous masses of virgin iron, many of which have rolled to the foot of the said range. From these masses, a middle sized one was taken to Tucson, where for many years it has remained in the plaza of said presidio.

Velasco noted that there were many of these enormous masses and that the one known as the Tucson Ring was only "middle-sized." Then where are the others? A second record was left by a forty-niner gold-seeker, A.B. Clarke, who wrote:

May 31ˢᵗ 1849 I obtained four mule shoes from the blacksmith, at one dollar apiece. The smith did not know how to put them on, although he was considered the best mechanic in town. I saw at this smith's shop a natural curiosity. It was a piece of native iron from a neighboring mountain, used for an anvil, and the only one in the shop. It was between three and four feet long, with two large legs, where [sic] were firmly set in the ground and judged by our men to weigh two thousand pounds. I hammered it and found it malleable.

It is doubtful that the blacksmith did not know how to shoe a mule. More than likely, he was tired of the incursions of *gringos* who were coming into the territory. A frontier blacksmith with an anvil would have been able to shoe any animal and make stirrups, spurs, guns, swords, chains and numerous domestic articles. Everyone in the garrison would have turned out to inspect the 1,400-pound piece of iron when it was hauled through the gates of the presidio. How they would have moved the meteorites from the present-day Santa Rita Mountains is another big question. The only wagons at the time were two-wheeled ones drawn by mules and oxen. The mountains are rugged, so most likely they used a travois, or sled constructed of cross planking. The meteorites could have been lifted on the sled with levers or block and tackle. When the Ring returned for a visit to the Flandreau Planetarium at the University of Arizona in 1976, it was quickly discovered that it was impossible to get a handhold on it, so it could not be lifted by manpower. Most likely, it traveled along the primitive road between Tucson and Tubac. Dr. John Lawrence LeConte, MD, traveled throughout the Southwest making scientific recordings. Although he was a medical doctor, his first love was entomology. In Yuma, he met Major Peter Heintzelman, who dubbed him Dr. Bugs. LeConte, the most important American entomologist of the nineteenth century, was responsible for naming and describing a large number of insect taxa, particularly beetles.

LeConte was vice-president of the American Philosophical Society (1880–83) and president of the American Association for the Advancement of Science (1873). He founded the American Entomological Society and was a charter member of the National Academy of Sciences. LeConte's thrasher was discovered by LeConte while on a beetle-collecting trip to Arizona and was named after him by George Lawrence. LeConte also took an interest in the Tucson meteorites and published his observations in the *American Journal of Science*. He wrote: "In February 1851 whilst at Tucsan [*sic*] in Sonora, I saw two large masses of iron, evidently meteoric, which were used as anvils by the two blacksmiths of that town. They were irregular in form and although imbedded in the ground to make them steady enough for use, they were about three feet high."

LeConte tried to get the Mexicans to cut off a piece of each of the meteorites, but in spite of the high price he offered, they replied, "Muy duro" ("Very hard"). He wrote that the pieces had been brought from a valley in a mountain chain—most likely the Santa Ritas—about forty miles southeast of Tucson. In this valley were to be found abundant pieces of iron of various sizes.

With the signing of the Treaty of Guadalupe Hidalgo in 1848, the border with Mexico had to be resurveyed, and Tucson would become part of the United States. President Zachary Taylor appointed John Russell Bartlett as the U.S. Boundary commissioner. Bartlett, a Rhode Island book dealer, was a scholar, bookseller, artist and author of *Dictionary of Americanisms*, but he knew nothing about surveying or managing men and money. His three years in the West were fraught with problems, and he often deserted surveying to satisfy personal curiosity. However, he was an astute observer, and his two-volume book *Personal Narrative of Explorations and Incidents in Texas, New Mexico, California, Sonora and Chihuahua 1850–1852* is an extraordinary record of life on the frontier. In 1852, Bartlett discovered a meteorite while camping near Tucson, where he purchased supplies, had wagons repaired and took care of the horses. He met General Miguel Blanco de Estrada, who had just returned from fighting Apaches. Bartlett made one of the most accurate sketches of the meteorites and wrote: "Called on General Blanco to take leave and while in town examined at the blacksmith's shop a single mass of native iron used as an anvil. This mass weighs some 600 lbs and was found about 20 miles distant where there is said to be more in larger masses."

Dr. Thomas H. Webb, the survey's surgeon and secretary, visited the military blacksmith shop and after much difficulty secured a piece of that meteorite for analysis. Two years later, while writing his personal memoirs of the survey, Bartlett wrote:

> *In the afternoon I called to take leave of General Blanco and at the same time examine a remarkable meteorite, which is used for an anvil in the blacksmith's shop. This mass resembles native iron and weighs about six hundred pounds. Its greatest length is five feet. Its exterior is quite smooth, while the lower part which projects from the larger leg is very jagged and rough. It was found about twenty miles distant towards Tubac. And about eight miles from the road, where we are told are many larger masses.*

By 1853, the United States was already sending out teams to survey the best railroad rights of way between El Paso and present-day Phoenix. Lieutenant John G. Parke, who was in charge of an early expedition, camped near Tucson on February 20, 1854. He introduced himself to Captain Hilarión García, who now served as the commandante of Tucson's Mexican garrison. Parke would be the first to report on both fragments of the meteorite. Captain Garcia showed him two specimens of meteorites found in a canyon in the Santa Rita Mountains about thirty miles south of

Tucson. They were both used as anvils, and one was in the military presidio while the other was in front of the alcalde's (mayor's) house. Parke was very much interested in the large Ring and described it as peculiar in form and weighing nearly 1,200 pounds. After two hours of hard work, Parke secured a few small chippings for analysis.

Dr. Charles Upham Shepard, Dr. J. Lawrence Smith and Dr. F.A. Genth all published their impressions in the *American Journal of Science*. Shepard was a mineralogist and held the chair of Chemistry at the Medical College of South Carolina. Genth was a geology professor and a chemist at the University of Pennsylvania. Smith was a professor of medical chemistry and toxicology at the University of Louisville. He was fascinated with meteorites and sold two of his slaves for seventy-three kilograms of iron mass. Shepard is the only person to ever report that there were three pieces of meteoric iron, the third of which was much smaller than the other two. If this was not a mistake, then it is a real mystery where the other piece went. He reported that the samples, weighing less than a quarter of an ounce, showed the natural exterior of a meteor but did not have a well-marked crust. Lawrence Smith expressed the hope that the topographic corps of engineers could bring the meteorites to "this country." Neither Genth nor Smith added much information on the composition of the iron masses.

James G. Bell, a member of a large cattle drive from El Paso, camped near Tucson on September 20, 1854. He was a rarity in that he was a cowboy who kept a diary. He described his close encounter of a dangerous kind with a Gila monster in addition to descriptions of the small Tucson chapel and its bell inside the presidio. Of the meteorites, he wrote: "In the same court is the blacksmith shop, a place of importance in these Mexican towns. The anvil used is quite a curiosity and came from a mountain of native iron fifteen miles distant. This piece of iron is above shape [Bell provided a rough but recognizable sketch of the Ring] as near as recollection can give it; one third is under ground."

In 1855, the boundary between Mexico and the United States was again surveyed. Major William Emory surveyed westward from El Paso, and Lieutenant Nathaniel Micheler surveyed eastward from Yuma. Micheler spent much of June in Tucson repairing his equipment and trying to obtain more mules. Captain Garcia and his troops were still protecting the presidio from Apaches. Micheler reported that a fine specimen of iron was to be found in the blacksmith's shop. John M. Pinkston, a Tucson resident, wrote to Major Emory reporting an iron mine about twenty miles southeast of Tucson where pure malleable iron was to be found and that two pieces had already been

brought to Tucson. In 1856, the Mexican troops withdrew from Tucson, but the meteorites remained in place, being much too heavy to move.

Ramón Pacheco, a blacksmith and merchant, took over the Ring meteorites. Ramón's father, Ignacio, had been born in Tubac and received, under the authority of the king of Spain, the Diamond Bell cattle brand, the oldest in the state. His third son, also named Ramón, was responsible for bringing the whalebone meteorite to Tucson. He knew where the enormous masses of virgin iron were located in the Santa Rita Mountains. He set up his blacksmith shop near the home of Guadalupe Santa Cruz, which would later become the Butterfield Overland Mail stagecoach stop. Ramón brought the whalebone slab into Tucson before 1851, probably on a travois towed by mules. Ramón's brother Miguel became both a justice of the peace and a mayor of Tucson as the town changed hands from Mexico to the United States. Ramón and Miguel took over as blacksmiths for the growing town. Many of the 1849 California gold-seekers stopped to rest in Tucson either on their way to California or on their way home after prospecting failure. Some of them settled in Tucson, and all of them needed the services of a blacksmith.

With the advent of the Civil War, both the Confederacy and the Union wanted the New Mexico Territory, which encompassed the present-day states of Arizona and New Mexico. For a little more than two months in 1862, Captain Sherod Hunter with his company of riflemen took possession of Tucson and raised the Confederate flag. When the California Volunteers under Colonel James H. Carleton arrived, they secured the territory for the Union. On June 7, Carleton declared martial law and dealt harshly with Confederate sympathizers. He gave orders that Pacheco's whalebone meteorite anvil in Tucson was to be seized and sent to San Francisco as a memorial to the California Volunteers. It was loaded on the next wagon train for Yuma.

What Carleton did not know was that the Ring Meteorite had already left Tucson and was on its way to California and then to the Smithsonian in Washington, D.C. In California, Pacheco's anvil moved to the mayor's office, the Pioneer's Association and the California State Mining Bureau Museum before joining its counterpart at the Smithsonian in Washington, D.C.

Brigadier General Bernard John Dowling Irwin, MD, would now control the fate of the Ring Meteorite. Irwin, a graduate of New York Medical College, was fluent in five languages and capable of a spitfire temper in all five. The Smithsonian Institution was established while Irwin was a medical student. His early reports of southern Arizona described in great detail the flora, fauna and geology of the area. He appears to have found the Ring in December 1857:

I found a large meteorite lying in one of the by-streets, half buried in the earth, having evidently been there a considerable time. No person claimed it, so I publicly announced that I would take possession of it in behalf of the Smithsonian, and forward it whenever the opportunity offered. Mr. Palatine Robinson, near whose house the iron was, assisted me in getting it sent to Humocilla [Hermosillo]. There was some expense attending its hoisting into the truck-wagon that took it down to Sonora and which I paid to Mr. Ainsa agreed to have it taken to Guaymas, Sonora, for fifty-dollars.

Joseph Henry, secretary to the newly founded Smithsonian, wrote to Irwin that the Smithsonian would gladly pay forty or fifty dollars for transport of the meteorite to Guaymas, where the American consul could arrange for its transportation to Washington, D.C. Over the next two years, Major Samuel Peter Heintzelman of the Sonora Exploring and Mining Company and Raphael Pumpelly both wrote of seeing the meteorites in Tucson. Pumpelly also described the Ring as having been moved. The journey of the Ring to Guaymas would take an additional two years. On February 3, 1861, Irwin wrote to the Smithsonian Board that the giant meteorite had begun its journey to Guaymas. Augustín Ainsa now controlled the fate of the Ring.

Earlier, the Ainsa family had taken part in the Crabb Expedition, wherein they tried to take over Sonora for the United States. Several American citizens had been murdered during this offensive. Augustín and his brothers, Jesús and Santiago, were not welcome on either side of the

Joseph Henry, director of the Smithsonian Institution, accepted the Tucson meteorites. *Courtesy Library of Congress.*

border but especially not in Mexico. In 1860, Augustín received a pardon from Mexico and was allowed to reenter his native country. Augustín had married Emilia Ynigo, and the Ring remained at the Ynigo ranch for two more years.

Finally, on June 9, 1863, the *Daily Alta California* reported that the Ring was on its way to Guaymas and that several wagons had broken down under its weight while on the way to the coast. The whalebone, or Carleton, fragment now stood in front of the San Francisco mayor's office while the Ring waited at the Guaymas customhouse. Santiago Ainsa was now ready to write up his history of the meteorites and take credit for getting the Ring to the Smithsonian. The Ring gradually became known as the Ainsa Meteorite.

The Ainsa family was of considerable means, and all three of the brothers graduated from St. John's College, now Fordham University. Santiago would go on to become an attorney. The Smithsonian was profuse in its gratitude to Santiago for providing a detailed history. Unfortunately, the Ainsa history was not true. He claimed to have received the history from their grandmother Ana Anza de Islas, the daughter of Juan Bautista de Anza, who saw the meteorite in Tucson in 1735. According to her, Captain de Anza intended to return the meteorite to Spain but gave up because of the difficult transportation over bad roads. He chose instead to leave it in Tucson. Santiago requested that the Smithsonian forward this information to St. John's College. This information was quoted and reprinted by the Smithsonian. Juan Bautista de Anza could not have seen the meteorite in 1735 because that is the year he was born. Perhaps his great-grandfather Juan de Anza was in the area in 1735. However, he was busy with the discovery of the rich Planchas de Plata, large slabs of virgin silver about twenty-five miles south of the present Arizona-Mexico border. There are no known accounts of the meteorites this early.

Ten days after Santiago sent off his "history" of the meteorites, Dr. Irwin, who had also been asked for any information on the Ring, wrote about his discovery to the Smithsonian. At the time, Irwin was on duty at a Memphis, Tennessee hospital during the Civil War, and he knew nothing of Ainsa's mischief. Irwin wrote that he could provide only a vague history of the meteorite that he had heard from elderly inhabitants of the Tucson presidio. They told Irwin that there had been a shower of meteorites about two hundred years earlier.

In November 1863, the Ring finally arrived at the Smithsonian. The institution wanted to give the Ring a name, so on November 9, Professor Baird wrote a letter to Santiago Ainsa showering him with gratitude and announcing that the Ring would henceforth be known as the Ainsa

Meteorite. Baird also wrote a note to Irwin thanking him for his efforts. All was quiet on the Smithsonian front until the *Annual Report* for 1863 was published in 1865. When Irwin saw the statement "It is proposed to call it the Ainsa Meteorite," he was furious. He wrote a letter to Professor Baird's superior, Secretary John Henry, on June 27, 1865. It read in part:

> *Sire: In tendering my obligation for a copy of the Smithsonian Report for 1863, I have the honor to call your attention to a very palpable and gross injustice done me in regard to the "Tuzcon [sic] Meteorite" presented and donated by me to the institution...After disclaiming to receive the freight for its transportation, the unwarrantable liberty of tendering it as a gift of himself and brother to the institution!...I presented it and it is my donation...the fact that Mr. Ainsa had it carried for me a certain distance is not valid reason why it should bear his name.*

Irwin requested that his communication be placed before the officers of the Smithsonian Institution at their next meeting so that they might take appropriate action. Joseph Henry immediately apologized to Irwin. He claimed to have no reason to disbelieve Ainsa, but because it had proven difficult to change the first name of a specimen, he proposed calling the specimen the Irwin-Ainsa Meteorite. The name was immediately put on the Smithsonian exhibit. Far from being happy with the compromise and the apology, Irwin prepared an eight-page pamphlet entitled the *History of the Great Tuzcon* [sic] *Meteorite Donated by B.J.D. Irwin, Surgeon U.S.A.* Irwin distributed the pamphlet to whomever he wished, and he sent a copy to Henry. The booklet included Henry's disavowal of Ainsa's claims. After the initial furor subsided, the matter lay dormant for about a decade.

When Irwin visited the Smithsonian, he discovered that the Ring still bore the name "Irwin-Ainsa Meteorite." Once again, he wrote to Joseph Henry about Ainsa's deceit. He added, "To continue my name linked to such an errant impostor I consider a disgrace." The usually gracious Henry became more and more irritable with Irwin but finally acceded to his demands, and the name was changed to the Tucson Meteorite. Then, in 1890, the *Arizona* (later Tucson) *Citizen* published a long article on the history of the meteorites and completely confused the roles of General Carleton and Irwin. Irwin lost no time in taking after the editor, who conceded to the newspaper's errors and printed a correction. Over the years, the University of Arizona tried to get the meteorites back to no avail.

And so the meteorites now stand in the Smithsonian Institution only a few feet from the Hope Diamond. On rare occasions, the meteorites have traveled to other sites, and the Ring came home to Tucson once with the opening of the Grace R. Flandreau Planetarium in 1970. However, no one has ever found the place where there are supposed to be so many more of these unusual stones from heaven. Their origin is still a mystery.

The Christmas Hatbox Baby

At dusk on Christmas Eve 1931, Edward and Julie Stewart were driving toward Phoenix when a flat tire forced Edward to pull off the road about ten miles west of Superior. While Edward repaired the tire, Julie wandered off into the desert. Before long, she heard what sounded like a baby crying. She returned to the car and asked her husband to come with her to investigate the sound. About one hundred feet from the road, the Stewarts discovered a black pasteboard hatbox with the lid fastened. When Edward kicked the box, they heard another cry. He opened the box and found a tiny red-haired baby girl in flowered pajamas. The Stewarts took the baby to the Mesa Police Department, where Constable Joe Maier was working late that Christmas Eve. Maier brought the baby to Helen "Ma" Dana, a midwife who ran a maternity house on the outskirts of town. Although the baby appeared to be in good health, she was wet, hungry and crying. Dana called a doctor who examined the tiny waif and pronounced the child to be about six days old. Ma Dana called the baby Marian, and the search began for her parents. Police combed the desert, fearing that the mother might have been killed or committed suicide, but they found nothing.

When her newspaper story hit the streets on Christmas Day, the blue-eyed red-haired little hatbox foundling stole the hearts of Arizonans. On Christmas Day, a Mesa jeweler gave her a gold locket. Ma Dana bought her a new dress, white shawl and pink-and-white booties. She received an outpouring of love and gifts, even though Phoenix, like the rest of the nation, reeled from hardships brought on by the Great Depression. Seventeen couples

Sharon Elliott was found in a hatbox by the side of the road on Christmas Eve. *Courtesy Sharon Elliott.*

applied to adopt Marian. On February 10, 1932, after hearing all the petitions for the child, Pinal County Superior Court judge E.L. Green awarded the baby to Faith and Henry Steig of Phoenix. He then cleared the courtroom of reporters and ordered the records sealed. The Steigs divorced not long afterward, but Faith retained custody of the hatbox baby.

Sharon Elliott did not learn that she was the hatbox baby until 1989. Elliott, a retired California aerospace worker, had decided to move back to Arizona because her daughter and son-in-law had been transferred to Mesa. She was shocked when her foster mother Faith Morrow, who suffered from terminal breast cancer, told Sharon that she had been adopted and was the famous Christmas hatbox baby. Elliott said, "My foster mother knew that I was moving back to Mesa and she did not want me to find out that I was adopted from someone else. She was afraid I would be hurt." Elliott was stunned. However, several members of her family knew that she had been adopted and her circumstances.

Elliott said, "I loved my foster mother. She was the only mother I had ever known, but after she died I wanted to know more about my real mother." After her adoptive mother's death, Elliott began a search to find her real mother. She contacted Alice Symon, a researcher with Orphan Voyage, an organization that helps adopted children find their real parents.

Symon provided free help because she had become so intrigued with the case. A Pinal County judge agreed to open the sealed records, but Elliott said, "They do not provide any clue about my real parents." Symon urged NBC's *Unsolved Mysteries* to air Elliott's story in 1989. The program explored

the possibility that the Stewarts knew more about the hatbox baby than they indicated and speculated that they made up the account of finding a baby by the side of a road to protect a young unwed mother. When the Stewarts heard these suspicions aired on *Unsolved Mysteries*, they became very angry and refused to discuss the case with anyone.

The program brought out a number of individuals who either claimed to be Elliott's mother or to know something about her circumstances. One man drove from Minnesota to see Elliott. He said he was her brother, but he also claimed to be the Lindbergh baby. None of the claimants convinced Symon that they were legitimate relatives of Elliott. In her heart, Elliott believes that there is still a possibility that her mother may be alive. If she ever finds her mother, she has several questions. "Why did you abandon me? What is your nationality? Exactly where and when was I born? Who was my dad, and why couldn't you keep me?"

So far the people who might have pertinent knowledge and the ability to answer these questions appear destined to take their secrets to their grave. Sharon Elliott may never get her answers, but on that 1931 Christmas Eve, the little hatbox baby opened the hearts of many people like another babe born in a humble manger many years earlier.

11
Tucson's White Lama

Theos Casimir Bernard was just one of many University of Arizona freshman who, in 1926, were dunked by upper classmates in the fountain of Old Main at the University of Arizona because they forgot—or probably chose not to wear—their freshman beanies. The fountain, which stands in front of the ROTC building, had been built to honor the Arizona veterans who gave their lives during World War I. Theos emerged from the pool and returned to his South Hall dorm for a change of dry clothes. However, after the pool dunking, he became quite ill with a high fever and chills and moved to the campus dispensary.

Theos had become an accomplished pianist by the time he graduated from Tombstone High School. His father worked for the Cochise County mines, and his mother was appointed as the Tombstone postmistress. Supposedly, his father, Glen Bernard, deserted the family shortly after Theos was born and went to India. Seven years later, his mother married Jonathan Gordon, a metallurgical engineer, who raised Theos as his own son. His stepbrothers, Dugald and Ray Gordon, sold newspapers and contributed much of their money to provide a university education for Theos. However, after a week of bed rest, he was no better. Theos was forced to drop out of the university and return to Tombstone. He experienced considerable pain traveling over the rough dirt road between Tucson and home. In the months to follow, he studied yoga on his own as a form of physical therapy. After a month of practice, he could once again bend his fingers, and he returned to the University of Arizona the next fall. But first, he decided to spend

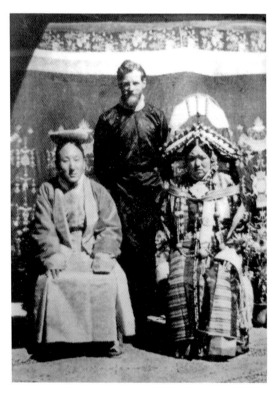

Theos Bernard, Tucson's white lama, posed with Tibetans. *Courtesy Columbia University.*

a summer in a mining camp, even though he had no interest in working as a miner. Instead, he lived a solitary lifestyle, read the Hindu classics and followed a strict regimen of hatha yoga exercises.

Theos's family had deep roots in Asian religion and philosophy. His mother, who practiced the Ba'hai religion, rather unusual in Tombstone, encouraged Theos's religious pursuits. His uncle Pierre Bernard had studied several Asian religions and formed the Nantucket Country Club, which provided training in yoga and an opportunity for discussing eastern philosophy with others. Theos attributed his continued interest in yoga to the appearance of a mysterious stranger from India who sought him out during his sophomore year at the university. In the tradition of eastern mysticism, the stranger declared himself a guru and asserted that Theos was his long-sought student. The guru then spent a night initiating Theos into the basic techniques of yoga.

At the same time, Charles Lindbergh appeared at the dedication of Tucson's Davis Monthan Air base. Theos was now supplementing his income as a dishwasher at the Copper Kettle restaurant on University Street just outside the university main gate. On October 21, 1931, Lindbergh came into the restaurant for lunch, and he met briefly with Theos. Ten years later, Lindbergh would be Theos's guest at a dinner for the Dalai Lama in India. Theos continued to pursue his studies and graduated with a law degree in 1931. During this period, he was awarded the Dwight B. Heard scholarship even though his grades were only average. He went on to obtain a doctorate in philosophy at Columbia University with the financial help of a research assistantship. There he met his wife, Dr. Viola Stern, MD.

After a whirlwind courtship, he married Viola in the spring of 1932 at his uncle's country club. Viola went on to become the first woman to complete medical training at Cornell University's medical school, and she served an internship in a New Jersey hospital. Later, Viola would found Columbia's Department of Community Mental Health program and become a leading figure in establishing psychiatric care for minorities. She would also serve as the president of the American Psychiatric Association. Theos transferred his course work to the Department of Philosophy at Columbia before setting off for India in December 1935. Theos and Viola left their boat at Shanghai and traveled by train to Canton, where they reboarded their boat and arrived in Calcutta in January 1936. With several letters of introduction to prominent British residents, they enjoyed several months of visits to the maharajah palaces, including elegant banquets and tours on elephants.

Theos searched for the guru who had visited him in Tucson only to discover that the man had died. However, his spiritual descendant still operated an ashram, or temple, in Bihor. He took leave of Viola and started a three-month study of hatha yoga in this ashram. These experiences were published in *Hatha Yoga: The Report of a Personal Experience* and *Penthouse of the Gods: A Pilgrimage into the Heart of Tibet and the Sacred City of Lhasa*. The books contain pictures of Theos in complicated yoga poses. This dedication to yoga exercises would improve the Tibetans' opinion of him when they admitted him for training in a famous Buddhist monastery in Llasa. Theos emerged as the "white lama" whose lectures on Asian philosophy captivated thousands of Americans during the Great Depression.

In 1937, Theos attended the World's Parliament of Religion in Calcutta, where he met Charles Lindbergh again. Theos reminded Lindbergh that his first meeting with the pioneer aviator had occurred when he, Theos, was a University of Arizona student washing dishes at Tucson's Copper Kettle. In his book *Penthouse of the Gods*, Theos described his Arizona upbringing and University of Arizona education as the best preparation that he could ever have received for carrying on research in this hidden corner of the world.

In New York, Theos achieved more notoriety rather than fame. The manager of Abercrombie and Fitch sued Theos for having deranged his wife with yoga exercises, for which she required psychiatric care that cost thousands of dollars. While Theos traveled to Asia, Viola began spending more time in New York pursuing her own career. They went through a

messy divorce in Las Vegas in 1942. Viola's charge was the usual one for the day—cruel and inhuman punishment. Theos charged her with the same accusation, but he did not want a divorce. He told the court that he came into this world endowed with the power to become the spiritual savior of mankind. Moreover, he was the spiritual and physical reincarnation of Guru Rinpoche, an ancient saint of Tibet. He wrote that he had occult powers that gave him control over the minds and bodies of men and women and over the physical universe as well. The court was not suitably impressed, and Viola was granted the divorce. Theos almost immediately found another rich wife.

He married Ganna Walska, an opera singer. Walska, born Hanna Puacz, Poland, changed her name when she became a diva and the toast of Paris, New York and Los Angeles. Thanks to most of her six lucrative marriages, she became very wealthy and devoted much of her later life to the construction of Lotusland near Santa Barbara. The Japanese-inspired garden at Lotusland was inspired by her love of the culture and her favorite opera, *Madama Butterfly*. It was here that Theos wrote his book *Penthouse of the Gods*. He wrote of the Tibetan terrain and the monasteries. In one chapter, it was evident that all was not peace and harmony. In one village, the citizens lined him up against a wall and almost stoned him to death before he was rescued by his servants.

Nevertheless, several Tibetan lamas were so impressed with Theos's devotion to their religion that they invited him to visit Llasa. Theos, the first American to enter the holy city of Llasa, became the only white man to be accepted into the lama priesthood. During his initiation, he visited the Tibetan Holy of Holies, which housed the tomb of the thirteenth Dalai Lama, and viewed a statue of the *Coming Buddha*, which stood several stories high. The lamas conferred their greatest honor on Theos when they welcomed him into their order by burning one thousand candles. Each candle contained two pounds of yak butter. Theos then took a devotional tour of all the sacred shrines of Llasa. Those lamas who accepted Theos believed him to be the reincarnation of the Guru Rinpoche, a Tibetan saint. However, at that time, Tibet had been without a Dalai Lama for two years, and not all Buddhists were pleased with Theos's initiation.

When Theos left Tibet, the lamas presented him with a rare copy of the *Kangyur*, the Tibetan religious encyclopedia, which consisted of 108 volumes of one thousand pages each. Servants sewed this treasure into yak skins, and they packed the volumes on twenty mules. Struggling

over the windswept eighteen-thousand-foot Himalaya pass and driving a caravan of one hundred yaks and mules through winter blizzards and across raging rivers made Theos homesick.

Theos described the yak as looking like a cow and a buffalo with a horse's tail. The animal could walk for fourteen days through snow without needing anything to drink. His caravan ate dried raw yak meat mixed with water and red pepper, which, when washed down with buttered tea and salt, tasted pretty good. However, Theos really wanted a good old American beefsteak. "In fact, just a cup of coffee and a hot dog would look like a banquet."

After completing his Tibet book, Theos returned to India to study the mysteries of hatha yoga with a revered guru. Once again, he returned to the United States and wrote a book on this subject. He decided that while yoga was beneficial to physical and mental health, he found no inherent mystery in the practice.

The mystery is what happened to Theos. His last communication with his family came in 1947, when he organized another Tibetan expedition. In 1953, his father petitioned to have Theos Casmir Bernard, Tucson's "white lama," declared legally dead so that he could close his son's $25,000 estate. Rumors circulated that he had been shot and killed while on a Tibetan trip in 1947. Supposedly, a group of Buddhists, intent on avenging the deaths of other Buddhists at the hands of Muslims, surrounded Theos's party. Like many Muslims, Theos wore a beard so that despite his protests that he was a Buddhist, he might have been murdered by Buddhists who did not know him. Another theory is that some of the lamas resented his removing treasures from Tibet.

Tibet has no cemeteries except for mausoleums for important religious personages, such as the Dalai Lama. If there is time before death, prayers are chanted by as many lamas as the dying person's relatives can afford. The corpse is taken to a burial hill, where the neck, wrists and ankles are tied to stakes with thongs. The hair is plucked from the body so that the soul may make an unhindered exit. After the bones have been picked clean by vultures, they are pulverized, mixed with water and scattered to the wind. Theos's Tibetan books were acquired by the Yale University library for an undisclosed sum from his estate. These books included the biographies of nine Dalai Lamas. The books were printed at monastic presses in Llasa, and each page was printed from a single block. The page edges were dyed a brilliant marigold, the color of the hats worn by the Dalai Lamas and their abbots.

One of Tucson's most colorful sons probably died a lonely, violent death in a faraway land. Still, the possibility that a mysterious white lama from Arizona lived to a ripe old age and died in a Tibetan monastery is the intriguing stuff of Shangri-la lore.

12

THE DISAPPEARANCE OF SALLY KLUMP

S ally Powers Klump grew up in Evansville, Indiana, but visited the Faraway Ranch in southeastern Arizona as a youngster. In Evansville, she graduated from North High School in 1960. An attractive, personable young woman, she was active in high school activities, was a member of the National Honor Society and was fêted at a scholarship recognition banquet at which she also received a special Spanish award. However, her experience of riding with Lillian Riggs, the blind boss lady of the Faraway Ranch, to Fort Bowie left an indelible impression, and she would return in 1968 to the ranch to make the same ride. For four years, she stayed at the cowboy house on Faraway and helped Lillian until she married Wayne Klump in 1972. Nevertheless, Sally would write and publish an impressive tribute to Lillian Riggs in the *Cochise County Quarterly*. Lillian may have been blind, but she kept a firm hand on the ranch operations; most workers did not last long with her.

John Sherman Klump was born on May 3, 1891, in New Mexico. He moved to Cochise County in 1905, seven years before Arizona became a state, and founded a large ranching empire. His marriage to Delia Ellen Knape in 1927 produced ten children. Three of his sons preceded him in death. The surviving children included a daughter, Doris, and sons Cornelius, Daniel, Richard, Wallace, Karry Keith and Wayne. He homesteaded on a 160-acre site between Willcox and Bowie, Arizona. Homesteaders in those days settled on their parcels and grazed their cows on adjacent federal public trust lands with little government interference. Ranchers would usually also claim water rights on the grazing rangeland. Life wasn't easy.

Sally Powers Klump lived at Faraway Ranch before she married Wayne. *Library of Congress.*

In modern times, the Klump holdings include thousands of acres of rangeland in Arizona's Cochise and Graham Counties and in New Mexico's Hidalgo County. Many are the stories of the Klumps' frugality, work ethic and clannishness. At one point, instead of signing his annual application for a cattle-grazing permit, Wally Klump crossed out several provisions, including from the top of the annual permit form the words "Grazing Lease Application," which he substituted with the handwritten words "Unconscionable Adhesion Contract." Wally included a check for $3,396 to cover his yearly grazing permit but also added the words "Paid Under Protest and Duress" under his signature. The Bureau of Land Management (BLM) declared the grazing lease invalid and took action. The BLM rounded up eighty-four head of Klump cattle near the Arizona–New Mexico border and sold them at auction.

The Klumps bought small ranches with whatever money they could scrape together. Bowie was a dot on the Arizona map, but land was cheap. In the 1940s, the Klumps invested every spare cent into property. During the school year, every day, one of the kids would stay home from school to build

Two-year National Honor Society members are (bottom row) Sally Powers, Susan Geier, Barbara Kirsch, Anne Bauer, Mary Ann Shelton, Jeanette Skinner; (middle row) Pat Allis, Mary Jo Hancock, Gwen Taylor, Merry Prusz; (top row) Don Zurstadt, Jerry Dassel, Keith Stavely, Larry Koch, Alan Eggleston, and Ron McAdams.

Sally Powers Klump is the first person on the left, bottom row. These were happier days that Sally shared with her friends in the Honor Society at North High School in Evansville, Indiana. *Photograph courtesy of Willard Library, Evansville Indiana.*

fences and work cattle. Being increasingly land-rich didn't put much money in John Klump's pockets. Their homes did not have electricity or indoor plumbing. Years later, when Wayne and Wally strung six miles of wire over the rugged terrain between their ranch homes, they created a self-contained telephone system.

Sally had fallen in love with the West, and she fell in love with Wayne Klump. She won an award in the annual Rex Allen Days parade with her special saddle arrangement, making her Tennessee Walker appear to float from the Riggs ranch. It was into this family that Sally Powers married, and a dark chapter unfolded over the Klump family. Wayne Klump, age twenty-eight, and Sally Ann Powers, age twenty-nine, were married on June 25, 1972, at the Faraway Ranch. Sally threw herself into the life of a rancher's wife. Two children were born to this union. At one point, Sally served as head of the women's division of the Santa Fe, New Mexico Chamber of Commerce. Under her direction, the women's division set about cleaning up part of Santa Fe in anticipation of the bicentennial celebration in 1976. She served as president of the Willcox Cowbelles, part of a state organization dedicated to the promotion of beef and scholarships for ranching families. She began writing a column, "Cowbelles Corner," for the *Arizona Range News* in 1976.

In January 1978, on a cold winter evening, Sally disappeared. According to the Cochise County sheriff's reports, Wayne Klump took five days to

notify the office of her disappearance. She apparently had no identification or personal belongings when she walked away. Several people reported seeing Sally in the years after her disappearance, but none of the sightings proved conclusive. Although there was no corpse or evidence of a crime, local law enforcement agencies felt that Sally had come to an untimely end, and the case is considered open.

Wayne secured a divorce on the basis of irreconcilable differences on August 17, 1978. He secured all of the community property and custody of the couple's children, Matthew Wayne and Kay Leslie. He subsequently remarried. He denies any wrongdoing in the unsolved mystery of Sally Klump's disappearance, claiming that she abandoned the family.

In 1990, the Klumps filed papers in Cochise and Graham Counties claiming about 300,000 acres—almost all of it on state or federal land. They based the claims on their interpretation of constitutional and common law, citing the family's long history in the area and their continued use of the rangelands. Wayne and Wally claimed "all minerals, coal, oil, gas, water, geothermal, gravel and all known and unknown substances to the center of the Earth. We claim the air, airspace, water, gases, all living things, all dead things and all substances to the heavens and beyond."

They locked gates on lands they leased and closed off several dirt roads in the Dos Cabezas Mountains after reading court decisions that said leaseholders could be held financially liable for injury and death on public lands. The locked-gates issue became news in southeast Arizona in 2015 after the state and the feds sued the Klumps and the Arizona Game and Fish Department brought criminal misdemeanor charges against Wayne Klump.

And still no one has satisfactorily answered the questions surrounding the disappearance of Sally Klump.

13
WHERE IN THE WORLD IS PAUL FUGATE?

These were the words on a bumper sticker circulated by the Friends of Paul Braxton Fugate. Fugate disappeared on January 13, 1980, from Chiricahua National Monument, Arizona. After several decades, park ranger Paul Fugate's disappearance while patrolling the Chiricahua National Monument remains a mystery. After extensive search and rescue procedures and rewards of up to $20,000, Fugate's remains have not been found, nor has a clue appeared as to what precipitated his disappearance.

Paul was born on September 2, 1938. He stood at five feet, five inches to five feet, ten inches and weighed 160 to 170 pounds. He had blue eyes, graying brown hair tied in a ponytail and a pronounced widow's peak. He had a beard and a moustache and wore thick glasses. He was last seen wearing his uniform, a National Park Service jacket (bright green with bright orange lining), shorts, white socks and green work boots. He left behind three cameras and a 1955 Chevrolet that he was rebuilding, along with some cash and traveler's checks. He also left an unfinished trail guide that he was writing, the organization of a scientific conference and an unsigned insurance policy with his wife, Dody.

On January 1, 1980, a friend of Paul and Dody Fugate, Becky Blanke, was about to be married to Ronnie Orozco up in the beautiful Pinery Canyon in the Chiricahua Mountains of southeastern Arizona. The wedding was set for noon so Paul could be there on his lunch hour. At this time, Paul, who was finishing up his master's thesis at the University of Arizona, was living at the Chiricahua National Monument ten days and in Tucson four days on a

Paul Braxton Fugate went for a hike in the Chiricahua Mountains and never returned. *Courtesy Dody Fugate.*

repeating schedule. On the monument, he had a three-room cabin, and in Tucson, he and his wife, Dody, had crammed 3,000 square feet of house into a 1,500-square-foot cottage. Dody, a photography technician, was working for a NASA project and on projects for the Steward Observatory and the Lunar Lab. She had driven out to the monument to attend Becky's wedding and intended to spend the night.

She returned to Tucson the next day. Paul came into Tucson on January 8, a Tuesday. He planned to drive back to the monument early because the car he was driving didn't have headlights. A seasonal interpreter had been visiting in Tucson but had left for Ecuador the week before, and Paul had promised to fix her headlights while she was gone. She had an old Volkswagen bug, and it needed help. Fixing cars was one of Paul's ways of relaxing, and he was always glad to help someone out.

This monument to Paul Fugate in the Chiricahua National Monument reminds people that he is not forgotten. *Author's collection.*

On Thursday, Paul met Dody for lunch at a small salad place on Park Avenue across from the university art building. They talked about where they were going in life and how to stay on track. They agreed that this long-distance marriage was beginning to pall, and Paul wanted Dody to move down to the monument. She saw two problems: Between them they had a lot of stuff, including a full photography studio and darkroom. Dody had two horses. They could not fit everything into Paul's tiny cabin. Dody was working on the Pioneer and Voyager flybys (space images), which was not only a prestigious project but also a lot of fun. Paul was equally passionate about Dody getting work with the first photographs of the Rings of Saturn sent by Pioneer to the Lunar Lab of the Astronomy Department at the University of Arizona.

Spectacular photographs from Saturn and Jupiter were coming in from Voyager II. In the beginning, Paul had wanted to be the astronomical photographer and Dody the ranger. Dody agreed that as soon as the flybys were over the following June, she would move to the monument. Paul said he would work on getting the upper bunkhouse at Faraway Ranch as housing so they would have more room and two bathrooms, as well as a place for a dark room.

Dody gave Paul a check for $200 to set up a bank account in Willcox. They had been having trouble because their check register was in Tucson with Dody, and Paul would often forget to tell her that he had written a check, leading to some surprises at the end of the month. While Dody was walking their dogs after Becky's wedding, she ran into strangers at Faraway Ranch. The ranch had been bought by the park service, but because the paperwork was unfinished, the ranch did not have signs or fences yet. Dody went to the stable and saw that someone had been moving stuff out and putting other stuff where it did not belong. Also, she saw several pickups come and go from around the ranch house. While she was sitting on a rock near the bunkhouse, a man drove up in a pickup, got out and began to approach her. At this time, her dog came back, and seeing the 175-pound dog sitting beside her, the man got back in his pickup and drove off.

Dody told Paul to push this incident with the park superintendent and suggest that someone (the Fugates) needed to be living down there to add a presence to the area. Paul thought this was a great idea because he wanted to put in a contact station and possibly an office in a small building across the road from the ranch house. Dody told Paul that the traffic of people seemed to be heavier on Sundays. He said he would also be using that argument, as it was a good one.

Paul had to remain at the monument longer than expected because Chief Ranger Bill Murray had been sent to Walnut Canyon as a temporary superintendent and Chiricahua was shorthanded. Also, Paul had set up a meeting with Forest Service and Bureau of Land Management (BLM) employees at the monument to discuss coordinating their policies on peregrine falcons. The Fugates agreed to think about the strategies for Dody to move in June. After their lunch, Dody and Paul continued to discuss various things as they walked east down Second Street to Cherry. At Cherry, they said goodbye; Paul went to their house, and Dody went to the Astronomy Department. After a few steps, Dody turned back and looked after Paul as he walked away. She never saw him again.

While this was going on in Tucson, in Cochise County, the Sheriff's Office was discussing setting up a roadblock in Rucker Canyon. Officers had heard that a shipment of drugs was coming through from the border east of Agua Prieta/Douglas. Rucker Canyon was the easiest pass to cross during the winter. The drug smugglers, on the other hand, also knew that Rucker Canyon was the prime way over the mountains and might have known that the sheriff's group was waiting there. They might have simply taken the next best route through Portal and over Onion Saddle. This route was longer

and higher, but it was open and went by the house of a man called Peabody who was a local "grower" and who had been dating one of the seasonal maintenance workers at the park. He would know what was going on along the west side of the Chiricahua Mountains. Unfortunately, the Onion Saddle road ended at Faraway Ranch.

On January 13, the superintendent was out deer hunting. The head of maintenance was at the NASCAR races in Tucson. The second maintenance man was visiting family near Nogales, and the third maintenance man was visiting family in Willcox. The administrative assistant and her husband were at Fort Bowie doing some catch-up work on files there, and the chief ranger was on extended duty at Walnut Canyon National Monument near Flagstaff.

Paul was there with a seasonal clerk. He had taken a group of hikers up to the top of the mountain so they could hike down and enjoy the perfectly lovely day. Paul and the seasonal clerk were griping to each other about being stuck in the office on such a beautiful day. He was writing one of those long boring reports called "What We Are Going to Be Doing for Interpretation in the Summer of 1980."

He told the clerk, "You go run [check out] a trail this morning, and I will cover the admissions desk. I will run one in the afternoon." Around 2:00 p.m., Paul finished his report and joked that the clerk would be spending her time typing it. She said he could type his own reports. They bantered a bit more before Paul stood up, picked up his new National Park Service parka with bright orange lining, turned and walked out the door by his desk. The clerk looked up but did not see him pass the window, so she believed he was headed down canyon toward Faraway. As he left, Paul told her, "If I'm not back by 4:30, close down without me."

Whoever saw Paul after that is unknown. Bill Murray, the chief ranger, was able to track him down through the Silver Spur Meadow and along the creek past Stafford cabin. He went to Faraway to see who was fooling around there on Sundays. About an hour later, Diane Cotsonas, a maintenance worker, came into the Visitor Center and talked to the clerk. Diane said she had not seen Paul on the trails up-canyon and asked if he was in.

Paul had a badge and was in uniform, but he wasn't armed. Later, while they were driving back from Fort Bowie, the Andersons, Joy and Ray (Joy was the administrative officer for the monument), saw a pickup drive past them going north. Ray said "There goes Paul Fugate, without his glasses!" Joy said, "Oh, Ray, everyone looks like Paul Fugate without his glasses."

Ray replied, "No, but he was in uniform."

Did they see Paul? We still don't know.

When Fugate did not return, the National Park Service and the Cochise County Sheriff's Department mounted extensive search and rescue efforts to find him in the twelve-thousand-acre park with numerous canyons. Rumors of marriage problems intimated that he wanted to disappear. However, his wife, Dody, believes that he was killed after stumbling onto a drug smuggling or illegal immigration operation. Others suggested that the park service was too conservative for him, and he just walked away.

In 1971, Fugate had been fired for violating park service regulations on long hair and mustaches. With his attorney, Edward Morgan, he fought his firing, and Paul was reinstated in 1976 with full benefits and back pay. Fugate was a nonconformist who pushed the boundaries on the park service's conservative grooming standards. Others believe that the real reason he was fired was that he was a whistle blower on an incompetent park employee. From the beginning, Paul Fugate seemed destined to have trouble with the National Park Service. He began his career at Carlsbad Caverns and quickly transferred to a small monument on the Navajo Reservation under a superintendent whom he considered an incompetent bully. When Paul transferred back to Carlsbad Caverns, he presented documentation on this person to the regional staff in Santa Fe. This superintendent was staunchly defended by the park service during an investigation.

The Group Superintendent John E. Cook, on his way to being a very important player in the NPS hierarchy, believed he could make the park service a better agency and return it to its core values. Cook wanted Fugate, whom he felt was not park service material, fired, so Paul was transferred to Chiricahua National Monument, where it was believed the superintendent would be amenable to his firing. The park service did not like Fugate's long hair and handlebar moustache. Bill Lukins was successful in getting Fugate fired. Paul set out to get his job back, and while fighting the dismissal, took classes at the University of Arizona to help him be a better naturalist. Paul got his job back, and Cook was sent to Alaska to solidify the conservation efforts up there. When Paul vanished, Jack Burke and his colleagues in the Western Region directed the investigation in a way that discredited Paul Fugate. Years later, an NPS/Interior Department detective reviewed the case and determined that Paul was the victim of a crime.

Howard Chapman, Western Regional director at the time, commissioned Peter Nigh, one of the park service's top criminal investigators, and an Arizona Department of Public Safety investigator to review the files and determine if there was anything else that needed to be done. On April

1, 1980, Paul Fugate was officially declared a "missing person." In accordance with the Missing Employee Act, Fugate was entitled to have an account credited with the same pay that he would have received if he had still been on the job. NPS sent Dody Fugate allotments from Paul's account. On February 23, 1983, the agency reviewed the Fugate case and declared that he was absent without authority and notified Dody that she was required to return the money that she had received with interest. On March 18, 1981, the agency sent Paul a letter informing him that he had been separated from the service due to his abandonment of his job. The NPS refused to certify that Fugate was dead and that Fugate's wife, Dody, was eligible for survivor's benefits.

Nigh and the Department of Public Safety (DPS) investigator reviewed the files of both the NPS and the Cochise County Sheriff's office, which included the witness statements and the search and rescue records. Based on the findings of this exhaustive review, Dody's application for survivor's benefits was reviewed and approved.

Jack Davis claimed that the only assumption the park service could make was that Fugate was AWOL or absent without leave. About six months after Fugate's disappearance, the park service began paying Dody half of her husband's regular salary. Later, the demand for repayment was changed to a lien on Paul's retirement fund. Dody was denied an appeal on the basis that a termination hearing must be requested within twenty days and dismissal was retroactive to 1980. With the help of an attorney, Dody successfully contested the park service's ruling.

In 1986, Cochise County sheriff's deputy Lieutenant Craig Emanuel announced that a murder arrest was imminent. The investigation led to out-of-state suspects. It was believed that Paul's disappearance was drug related, but it was not believed that he was in any way involved in drugs. Subpoenas were issued to out-of-state witnesses, but the case against the suspects was circumstantial and eventually dropped. Supposedly, in 1983, a police informant in another state told officials that an individual had confessed to killing and burying a law enforcement officer in the area of Fugate's disappearance. Voluntary lie detector tests by park service employees and Dody eliminated many possible leads. Fugate's disappearance was changed from missing person to homicide.

In 1988, Pima County Superior Court commissioner Gordon S. Kipps declared Paul Fugate legally dead. Barbara Elfbrandt assisted Dody in this legal quagmire. After this declaration, Dody could collect monies that Fugate had willed to her, and she could obtain a death certificate and collect death

benefits from the government. She still had to wait a period of time during which Fugate's family could contest the will.

On January 13, 2010, Dody Fugate, Paul's widow, held a memorial service to commemorate the thirtieth anniversary of this tragic event. A dozen family friends and Chiricahua National Park Service employees gathered at Faraway Ranch and shared stories and memories of Paul.

Several people tried to get the Federal Bureau of Investigation involved, but it declined on the basis that it had no jurisdiction because there was no evidence that a crime had been committed. Despite extensive searches conducted by employees of the National Park Service, Cochise County Sheriff's Department, Bureau of Land Management, U.S. Forest Service, U.S. Border Patrol, customs, the Southern Arizona Search and Rescue Association and Fugate's many friends, no trace of the park ranger was ever found. The only items missing from Fugate's home in the monument were the uniform he was wearing and his keys. To this date, nothing has ever been discovered to explain his mysterious disappearance.

BIBLIOGRAPHY

BOOKS

Ball, Larry D. *The United States Marshals of New Mexico and Arizona Territories, 1846–1912*. Albuquerque: University of New Mexico Press, 1992.

Covey, Cyclone. *Calalus: A Roman Jewish Colony in America from the Time of Charlemagne Through Alfred the Great*. New York: Vantage Press, 1975.

Dinock, Brad. *Sunk Without a Sound: The Tragic Colorado River Honeymoon of Glen and Bessie Hyde*. Flagstaff, AZ: Fretwater Press, 2002.

Fuller, John G. *The Great Soul Trial*. New York: Macmillan, 1969.

Glover, T.E. *The Lost Dutchman Mine of Jacob Waltz*. Vols. 1–2. Phoenix, AZ: Cowboy-Miner Productions, 1998.

Leavengood, Betty. *Grand Canyon Women: Lives Shaped by Landscape*. 2nd ed. Grand Canyon, AZ: Grand Canyon Association, 2007.

Mavity, Nancy B. *Sister Aimee*. New York: Doubleday, 1931.

McClintock, James H. *Arizona, Prehistoric, Aboriginal, Pioneer, Modern: The Nation's Youngest Commonwealth within a Land of Ancient Culture*. Vol. 2. Chicago: S.J. Clarke, 1916.

McPherson, Aimee Semple. *This Is That*. Los Angeles: Bridal Call Publishing House, 1923.

Metz, Henriette. *Pale Ink: Two Ancient Records of Chinese Exploration in America*. Cincinnati: University of Ohio Press, 1972.

Osis, Karlis, and Erlendur Haraldsson. *At the Hour of Death*. New York: Hastings House, 1977.

Sloan, Richard E. *Memories of an Arizona Judge*. Stanford, CA: Stanford University Press, 1932.

Thomas, Lately. *The Vanishing Evangelist*. New York: Viking Press, 1959.

Walters, Lorenzo D. *Tombstone's Yesterdays*. N.p., 1928.

Willey, Richard R. *The Tucson Meteorites*. Washington, D.C.: Smithsonian Institution Press, 1987.

Bibliography

Ephemera

Arizona Historical Society Ephemera Files. Tucson, Arizona.

Author's communications with Dody Fugate.

Author's correspondence with the American Society for Psychical Research, Inc. New York.

Copy of James Kidd's will, Arizona State Archives. Phoenix, Arizona.

Elliott, Sharon. Interview with the author. December 2001

Gregory Davis Superstition Mountain Collection. Apache Junction, Arizona.

Johnny Rube Collection, Arizona Historical Society. Tucson, Arizona

Microfilm record of the case of the estate of James Kidd, Deceased No. 36.1.751, University of Arizona Law Library. Tucson, Arizona.

Richard Y. Murray Papers, Western Archeology and Conservation Center. Tucson, Arizona.

Sally Klump divorce, Cochise County Superior Court Records. Bisbee, Arizona

Sally Klump high school records, North High School. Evansville, Indiana.

Smithsonian Annual Report, 1863.

Theos Bernard file, Columbia University Library, New York.

Wham Paymaster Ephemera file, Arizona Historical Society. Tucson, Arizona.

Wham Paymaster Papers, National Archives. Laguna Niguel, California.

Manuscripts and Articles

Bent, Thomas, Sr. "History of the Silverbell Artifacts." Unpublished manuscript in possession of the author.

Upton, Larry T., and Larry D. Ball. "Who Robbed Major Wham? Facts and Folklore behind Arizona's Great Paymaster Robbery." *Journal of Arizona History* 38, no. 2: 99–134.

Newspapers

Arizona Daily Citizen

Arizona Daily Star

Arizona Range News

Arizona Republic

Arizona Weekly Gazette

Bisbee Review

Daily Alta California

Douglas Dispatch

Los Angeles Times

New York Times

Phoenix Daily Herald

Phoenix Gazette

Phoenix New Times

Reno Evening Gazette

Santa Fe Times

Tucson Daily Citizen

Yuma Daily Sun

INDEX

INDEX

INDEX

T

Taylor, President Zachary 92
Thomas, Julia 27
Tibet, Llasa 106
Treaty of Guadalupe Hidalgo 1848 92
Tustian, Maxine 82

U

Unclaimed Property Act 81
U.S. Army Corps of Engineers 9

V

Valko, Stephen 41
Velasco, José Francisco 90
Vorhies, Charles 23

W

Walker, Mary June 37–38, 40–42, 44
Walska, Ganna 106
Waltz, Jacob 27
Washum, Sheriff Jim 39
Weaver's Needle 30
Webb, Gilbert 48–53, 55
Webb, Wilfred 48–49, 51–52, 55–56
Wham, Lieutenant Joseph Washington
 3, 45–51, 53–56
Wheeler, Private James 46
White, Mayor John E. 24
Williams, Private Squire 46
Will, James Kidd 81
Wollard, Gus 73
Woods, Ray 42

Y

Yale University 107
Young, Private James 46
Yuma Civil Air Patrol 37

ABOUT THE AUTHOR

J ane Eppinga is a member of Western Writers of America, Arizona Professional Writers, National Federation of Press Women, Society of Woman Geographers and the Southwestern Watercolor Guild. She is a graduate of the University of Arizona with bachelor's degrees in fine art and biology. Her biography, *Henry Ossian Flipper: West Point's First Black Graduate* (Republic of Texas Press, 1996), was part of a package presented to President Clinton as a successful appeal to have Henry Ossian Flipper posthumously pardoned. Her other books include *Arizona Twilight Tales: Good Ghosts*; *Tucson, Arizona*; *Nogales, Arizona: Life and Times on the Frontier*; *Tombstone: Apache Junction and the Superstition Mountains*; and *They Made Their Mark: An Illustrated History of the Society of Woman Geographers*. She also wrote

the chapter "Ethnic Diversity in Arizona's Early Mining Camps" in *History of Mining in Arizona*, volume two, and the chapter "Day of Infamy" in *Arizona Goes to War*. On July 5, 2009, she presented a paper based on *They Made Their Mark: An Illustrated History of the Society of Woman Geographers* before the Tenth International Interdisciplinary Congress in Madrid, Spain. Her book about southern Arizona cemeteries was released in March 2014.